THE
SECOND
WORLD WAR
IN COLOUR

THE
SECOND
WORLD WAR
IN COLOUR

Ian Carter

Published by IWM, Lambeth Road, London SE1 6HZ
iwm.org.uk

ISBN 978-1-904897-42-2

A catalogue record for this book is available from the
British Library.

Printed and bound in the UK by Gomer Press.

Every effort has been made to contact all copyright holders.
The publishers will be glad to make good in future editions
any error or omissions brought to their attention.

10 9 8 7 6 5 4 3 2 1

Front cover image: © IWM (TR 2145) (see page 107)
Back cover image: © IWM (TR 1920) (see page 88)

CONTENTS

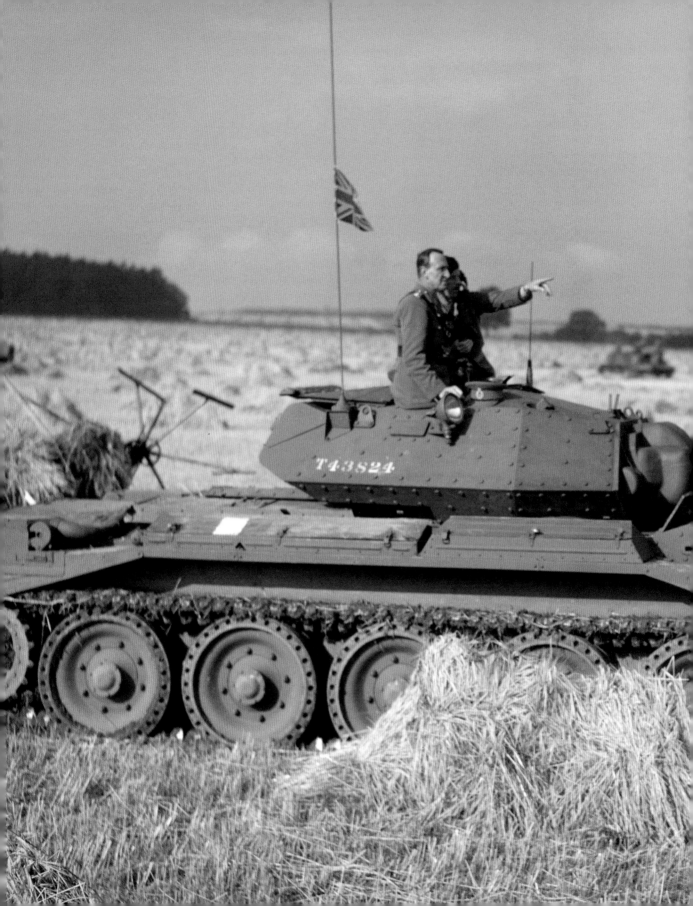

INTRODUCTION

To most of us, the Second World War is a black and white war. Despite the advent of computer colourisation techniques in recent years, we are still accustomed to viewing the conflict through monochrome film and photographs. Colour film was a relatively rare commodity during the war, and that rarity was compounded further by the difficulty and high cost of reproducing it in printed works. But the images that were created have the power to shock and impress us even now. The vivid hues of flames and fabrics, the intense blue skies, the sun-tanned faces and the myriad colours of military camouflage and markings all stand out. The photographs appear to have been taken yesterday rather than 75 years ago. A selection of them are presented in this book, chosen from the extensive collection held in the Photograph Archive at Imperial War Museums (IWM).

The nineteenth century saw many experiments to develop colour photography, but the first practical process was the autochrome, invented by the French Lumière brothers at the beginning of the twentieth century. Though surprisingly effective, the photographic plates were expensive and long exposure times meant they were only really suitable for static subjects. More commonly, black and white images were hand painted to give some impression of reality, or the film itself was tinted with dyes to add one or two colours. In 1936 colour photography came of age with the introduction of a 35mm transparency film called Kodachrome by the Kodak Company in America. In the same year, Agfa in Germany produced a similar product called New Agfacolor, which benefitted from a simpler processing technique. Alongside the new products came advances in printing techniques which meant that colour images could now finally be reproduced and published commercially. Most of the colour photography of the Second World War would be shot on film stock produced by these two companies.

The majority of images in this book are the work of a select band of official photographers serving with the British armed forces, using a stock of Kodachrome film obtained from the United States. The Ministry of Information (MOI), which controlled the output of material to the press, was keen to obtain a selection of colour images for both record purposes and for inclusion in those publications able to reproduce colour. In the end, some 3,000 images were taken, covering the period 1942–1945, but not all survived. Around 1,500 of them – those which had not been censored and deemed fit for publication during the war – were passed to IWM for preservation in 1949. The rest have been lost.

The British official colour collection encompasses a wide variety of subjects, but coverage is by no means comprehensive and reveals the changing MOI priorities of the time. Many photographs had obvious propaganda value, while others were taken merely to test techniques in a process still relatively untried in Britain. The film was a precious commodity and in many cases only one or two frames were exposed of any particular scene. The majority of images were taken on the home front, illustrating aspects of war production, agriculture and domestic life as well as the activities of the armed forces. The home-based Royal Air Force (RAF) was particularly well photographed in the mid-war years, reflecting its importance in the defence of Britain and the expanding power of the bomber offensive against Germany.

Colour film was also used to record British operations overseas, particularly in the Mediterranean theatre, where the role of the RAF was again well represented. The collection

includes many striking shots of the campaigns in Tunisia, Sicily and Italy where azure skies, parched deserts and imposing mountains provide exotic backdrops. Unfortunately, the war at sea received much less attention, and the result is a disparate selection of images limited to scenes in a Royal Navy submarine, portraits taken on board a number of surface warships and the odd glimpse of Fleet Air Arm carrier operations. The campaign in north-west Europe in 1944–1945 was accorded only patchy coverage, despite its significance. No colour film was made available to British official photographers covering the D-Day landings. Sadly, but perhaps understandably given the logistics of supplying the film and getting it processed in specialist labs, the war in the Far East was virtually ignored. Nevertheless, despite these yawning gaps the British official colour collection provides an invaluable visual record. The images may on occasion appear stilted and posed – exposure times were still appreciably slower than with black and white film – but they are invariably sharp, with well-saturated colours. They give us an unusually candid view of Britain, her population and armed forces at war.

The MOI also acquired and distributed colour photographs taken by commercial news agencies, such as Fox Photos, Sport & General, and Keystone. Many images of the RAF in Britain were taken by the noted freelance aviation photographer Charles E Brown, who also supplied some of his work to the MOI. A few photographs in this book are German, taken on Agfa colour film by photographers accompanying the Wehrmacht into action. They served as a vital propaganda tool and many appeared in the popular magazine *Signal*, intended for foreign rather than domestic German distribution. Other photographs presented here come from American sources. Unsurprisingly, Kodachrome film was more readily available to US service personnel and was used for both private and officially sponsored photography on a scale unseen elsewhere. Restrictions on private photography were less severe than in Britain's armed forces. Some of the most dramatic images were taken by aircrew of the United States Army Air Force (USAAF) on combat missions, something that was virtually unheard of in the RAF.

This book is by no means intended to be a comprehensive history of the Second World War. The conflict's major themes and events are explored in the introductory texts to set the scene, but its structure and content have for the most part been dictated by the range of images available. The war is seen here from a mainly British perspective, reflecting the nature of IWM's photographic collection. All the captions are expanded and newly researched, as wartime censorship meant that the originals are invariably vague and incomplete.

Black and white photography puts a barrier between subject and viewer, no matter how graphic its content. It can be used to great effect for artistic purposes, but can take away the immediacy required of a journalistic image. Colour photography restores that missing clarity and impact. As the most destructive war in history fades gradually from living memory this becomes ever more important. I hope that the selection of images in this book will take away its remoteness and bring the Second World War to life.

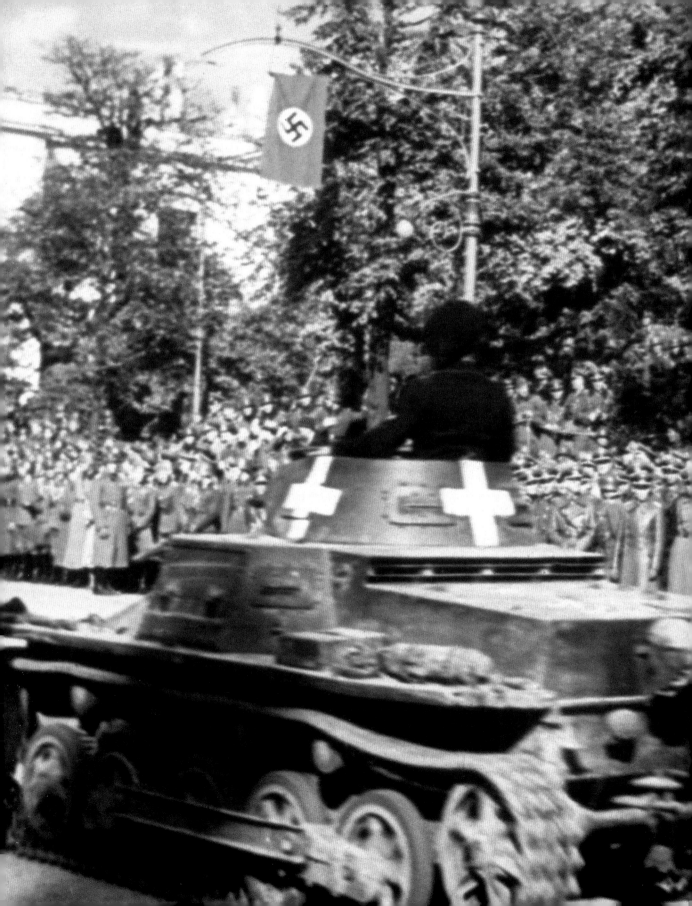

Chapter One
GERMANY TRIUMPHANT

After coming to power in 1933, Hitler embarked on a massive rearmament programme and an aggressive foreign policy. His aim was to redraw the map of Europe with a powerful Germany at the centre. He surmised that the western powers, fearful of another European war, would not intervene. Hitler's initial conquests were bloodless, as the Nazi state absorbed Austria and subjugated Czechoslovakia. In September 1939 he invaded Poland with the connivance of the Soviet dictator Joseph Stalin. This time Britain and France stood up to him. The Second World War had begun.

Hitler did not anticipate a long conflict, nor was his nation equipped to fight one, especially on two fronts. He gambled on western inaction while he destroyed Poland. Fortunately for him, France and Britain did nothing to help the beleaguered Poles. The French preferred to adopt a defensive policy, while Britain despatched a small expeditionary force to France, and sent bombers to shower Germany with leaflets. The Polish campaign lasted less than a month, with German armoured divisions and the Luftwaffe cooperating to great effect. Poland was dismembered by Germany and the Soviet Union, and its people now found themselves at the mercy of their occupiers.

After this victory, Hitler was keen to turn against France but was persuaded by the German High Command to wait for the following spring. The winter of relative inactivity became known in Britain as the 'Phoney War'. On 9 April 1940 the Germans struck again, this time against Denmark and Norway. Britain and France despatched forces to help the Norwegians, but the campaign was a disaster. The resulting political crisis saw the British prime minister, Neville Chamberlain, agree to step down. In his place came Winston Churchill.

On 10 May 1940 Hitler launched his assault on France, Belgium and Holland. The French Army was large and well-equipped, but its command structure was weak and morale was low. The Germans had hatched an audacious plan to advance as expected into the Low Countries in the north, but delivered their main armoured thrust through the Ardennes in the south. The French defensive fortifications known as the Maginot Line were outflanked, and fast-moving German motorised units penetrated deep into northern France, splitting the Allies. The British Expeditionary Force was cut off and expelled from Dunkirk. The French Army collapsed. The campaign was over in six weeks.

Hitler was exultant. The speed of the German victory surprised everyone. Now he was faced with a strategic dilemma. It seemed natural to continue with an invasion of Britain, and he gave orders for preparations to begin. But he was already considering war with the Soviet Union. Hitler believed that the territorial needs of Germany – *Lebensraum*, or 'Living Space' – could only be met in the east. Here too were populations that could be exploited and subjugated according to the racial and ideological beliefs underpinning the Nazi state.

Hitler therefore put out a peace offer to Britain, which was ignored. Churchill was busy motivating the nation for its finest hour. Hermann Goering, head of the Luftwaffe, promised Hitler he could win the air superiority over England required for an invasion. The Battle of Britain proved otherwise, and the RAF inflicted a decisive defeat on the Luftwaffe. This setback persuaded Hitler to turn against the Soviets. Meanwhile Hitler's Axis partner, the Italian dictator Benito Mussolini, was keen to share the spoils and had embarked on his own programme of conquest. The Italians attacked

British forces in Egypt and invaded Greece, but suffered a bloody nose in both. Hitler was obliged to come to his aid. German forces conquered Yugoslavia and pushed the British out of Greece. An expeditionary force was also sent to Libya, beginning a campaign which swung to and fro across the deserts of North Africa for the next two years.

In June 1941, Hitler launched Operation 'Barbarossa' – the invasion of the Soviet Union. It was the climax to Hitler's ambitions for conquest, and his ultimate gamble. Some German generals had doubts, but after the stunning success in France many believed this too would result in a resounding victory. The Germans attacked on a front stretching from the Baltic to the Ukraine, and the initial advance was spectacular. Entire Soviet armies, disorganised and poorly led, were encircled and destroyed. By September Leningrad was besieged, and Kiev and much of the Ukraine captured. In the centre the Germans were within 200 miles of Moscow.

But Russia was very different to France. The distances were immense, the transport infrastructure poor. Supply was a major problem, especially for the panzer divisions in the lead. Despite huge losses in men, tanks and aircraft, the Soviets fought on. The Germans had gravely underestimated the numerical strength of their opponents, and their will to resist. Their own losses were higher than expected, too. In October they embarked on a major offensive to finally capture the Russian capital. Again, vast numbers of Soviet troops were captured. German troops got to within distant sight of the Kremlin, but no further. In bitter winter weather the Soviets counterattacked, pushing the Germans back. Hitler's armies had suffered their first defeat.

PREVIOUS PAGE
The Second World War began when Britain and France declared war on Germany after its invasion of Poland on 1 September 1939. Hitler had already concluded a non-aggression pact with his ideological enemy, the Soviet Union, which launched its own assault from the east two weeks later. The Poles fought hard, but Hitler's armies triumphed by combining traditional encirclement tactics with a new form of mobile, combined-arms warfare called Blitzkrieg ('Lightning War'). The Soviet Army performed badly, which encouraged German plans for further expansion. Here, Hitler and his generals view the German victory parade in Warsaw, 5 October 1939.

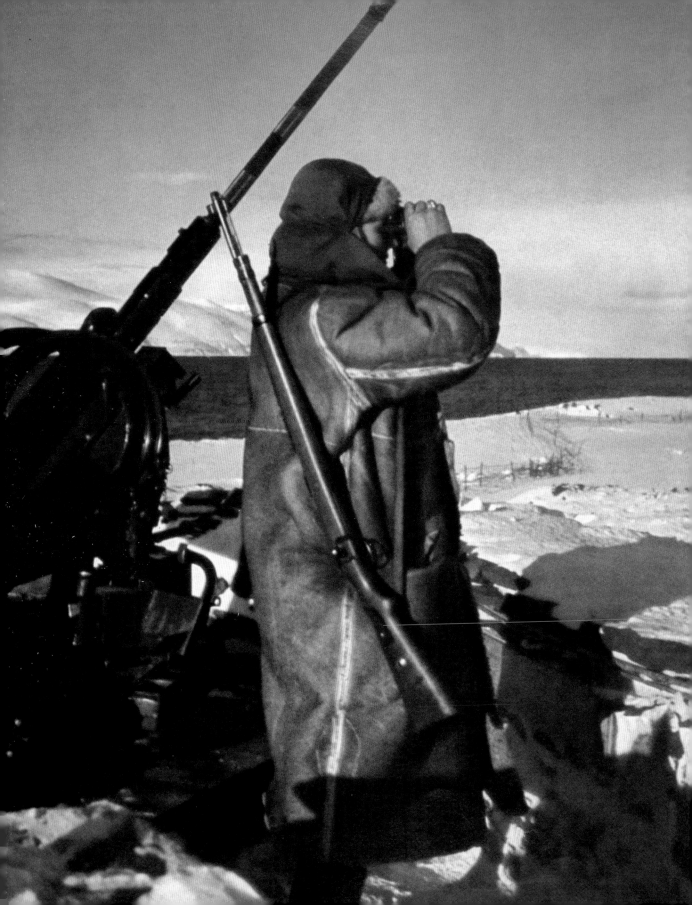

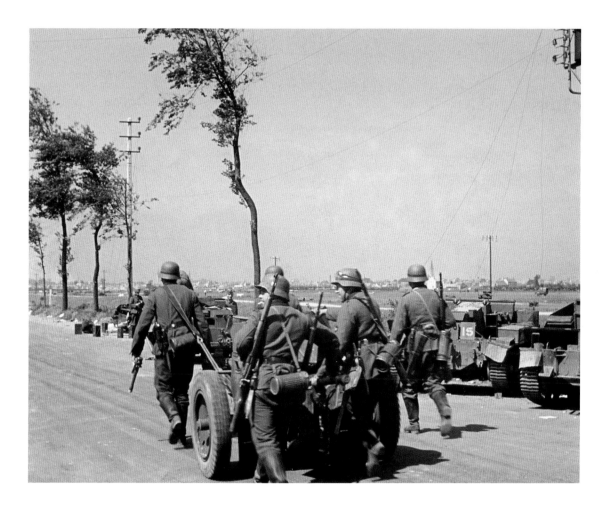

◀ **A German sentry in the frozen north of Norway, 1941.**
Hitler attacked Norway in April 1940 to obtain naval bases and safeguard the passage of vital Swedish iron ore imports via the ice-free port of Narvik. British and French forces intervened but were quickly expelled and the country remained under Nazi control until the end of the war. The British restricted themselves to small-scale commando raids, despite Churchill's enthusiasm for a major assault. Hitler also obsessed about an Allied invasion of Norway, which meant 350,000 troops were tied up on defensive duties when they might have been more usefully deployed elsewhere.

▲ **German troops drag a 3.7cm anti-tank gun past abandoned British Bren gun carriers outside Dunkirk, June 1940.** Some 338,000 British and French troops had just escaped across the Channel in warships and civilian vessels. But Britain's new prime minister, Winston Churchill, warned that 'wars are not won by evacuations'. The German conquest of France, which had begun on 10 May, was almost complete. The French Army, demoralised and badly led, had collapsed. Other British forces still in the country were evacuated through Le Havre and the Atlantic ports. The French signed a humiliating armistice on 22 June, and Hitler revelled in his triumph.

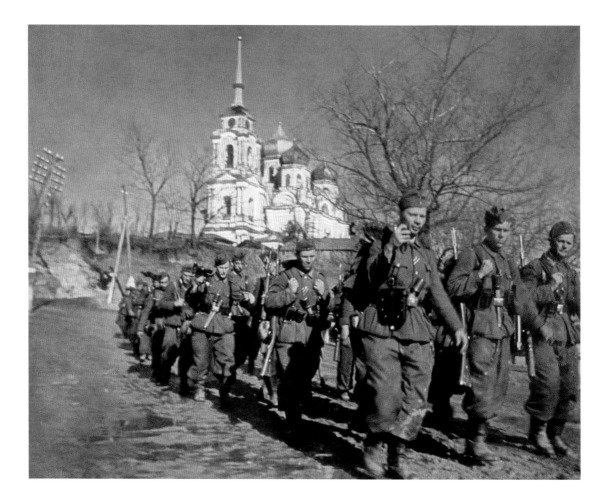

In June 1941 Hitler committed his forces to an invasion of the Soviet Union. Operation 'Barbarossa' involved 3.6 million men, 3,600 tanks and 2,700 aircraft. It was the largest military assault in history, and the prime objective was the rapid destruction of all Soviet armies in the western USSR. The panzer divisions led the way, and vast numbers of Soviet troops were killed and captured in huge encirclement battles. But as in previous Blitzkrieg campaigns, the majority of German troops – like the infantry in this photo – had to advance on foot.

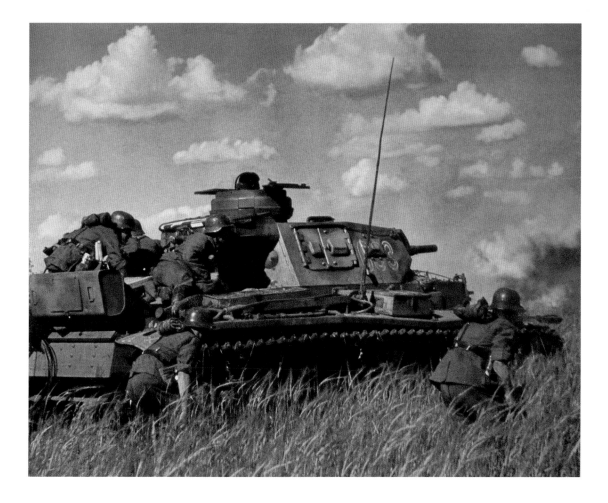

A German PzKpfw III tank and infantry in action on the Eastern Front, summer 1942.
The Soviets had stopped the German drive on Moscow during the winter of 1941. In early 1942 Stalin ordered a general offensive along the entire front, but his forces were badly handled and made only limited gains. The Germans won spectacular victories in the Crimea and around Kharkov in the Ukraine, netting over 400,000 Soviet prisoners. In June, Hitler launched a major offensive of his own in the south, hoping to capture the oil fields of the Caucasus. Though successful at first, his over-extended forces would ultimately meet defeat at Stalingrad. The war was already lost for Germany.

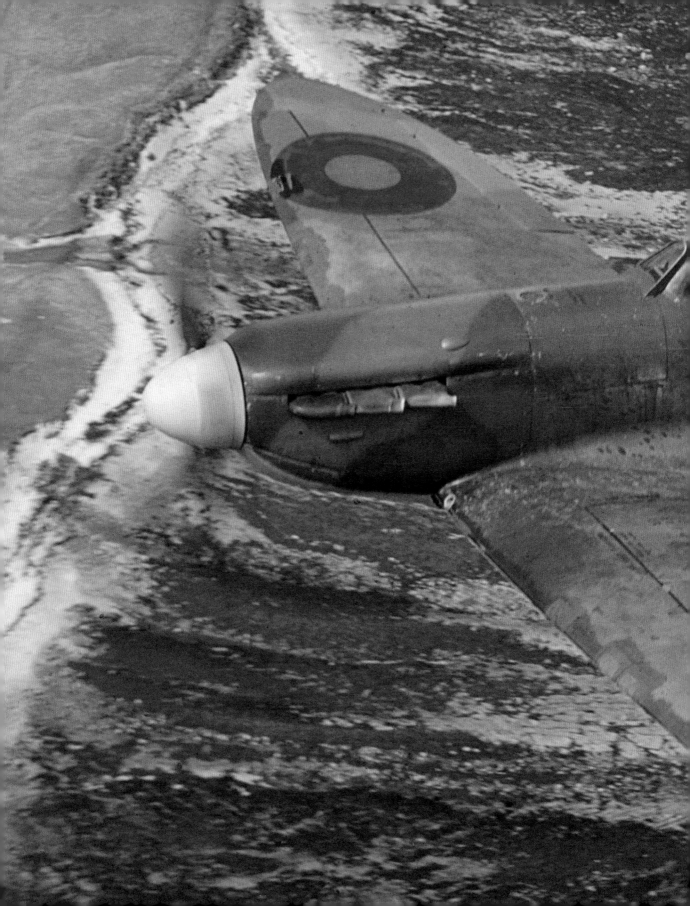

Chapter Two
BRITAIN AT WAR

At the outbreak of war, the people of Britain had been conditioned to expect an immediate rain of death from the skies through aerial bombing and the use of poison gas. Public air raid shelters were prepared, children were evacuated from cities and gas masks were issued. Hospitals readied themselves for up to two million casualties. However, the expected mass Luftwaffe bombing raids failed to materialise. Instead, the RAF skirmished with small numbers of German aircraft carrying out reconnaissance missions and attacks on naval bases in the north. At sea there was immediate action, as U-boats began a campaign against British merchant shipping and the Royal Navy engaged German surface raiders. But for now, Britain itself was spared the conflagration predicted by many during the 1930s. Accidents in the blackout posed the biggest threat to people trying to resume their normal lives. This so-called 'Phoney War' lasted until the spring of 1940 when Hitler's conquest of Norway and France suddenly brought the war to a crisis point.

The British Army was evacuated from Dunkirk. Invasion seemed imminent. Over a million men not eligible for military service came forward to join the Local Defence Volunteers, later known as the Home Guard. Some in government contemplated making peace with Germany. The key opponent of this position was Winston Churchill, who was summoned to be prime minister after the fall of Neville Chamberlain. Churchill, now head of a coalition government, could offer only 'blood, toil, tears and sweat'. But his resolute will to resist Hitler and fight on inspired the nation. That summer the RAF won a famous victory in the skies over southern England, thanks in great part to a well-organised and effective command and control system which was only just ready in time. The Luftwaffe's failure during the Battle of Britain persuaded

Hitler to turn his armies eastwards against the Soviet Union. He hoped to starve Britain into submission with U-boat attacks on shipping and air attacks on ports.

Invasion had been deterred, but Britain was to suffer years of aerial bombing. The home front became a battlefield. Many men and women served in Civil Defence, as air raid wardens, ambulance drivers, fire-fighters and rescue workers. 2,379 of them were killed. The most sustained period of aerial attacks was known as the Blitz, the period from September 1940 to May 1941 when the Luftwaffe concentrated on London, but also raided cities throughout Britain. The centre of Coventry was destroyed in one night in November 1940 and 568 people were killed. There were further periods of bombing later in the war as Hitler demanded retaliation for RAF bombing raids, but the attacks were smaller in scale and prohibitively costly for the Luftwaffe, as Britain's air defence network had grown in size and effectiveness. In 1944 the V-weapon campaign saw pilotless V1 flying bombs and V2 rockets launched at London. The morale of a war-weary population was affected by the random nature of these weapons, but the attacks ultimately proved futile. In five of years of bombing, a total of 60,595 civilians were killed in Britain.

From the outset, British industry was mobilised for total war. Tank and aircraft production soon outpaced that of Germany, whose economy was initially inefficient and badly organised. The Emergency Powers Act brought all aspects of the nation's economy under tight government control. Food, clothes and petrol rationing was introduced. Skilled labour was always in short supply. From 1941 workers were obliged to remain in jobs deemed essential for the war effort. Women were conscripted, and could choose between the uniformed auxiliary services,

factory work or farming. By 1944 a third of the population were employed in such vital industries as munitions, ship-building, aircraft production, transport and agriculture. Almost 7 million of these workers were women. Only the coal mines remained an entirely male preserve, where labour shortages forced conscription of miners in 1943 – the so-called 'Bevin Boys'.

In 1942 the first of over a million and a half US servicemen started arriving in Britain. The Americans came with two objectives. The first was to conduct a strategic bombing campaign against Germany from British airfields. The second was to use Britain as the springboard from which to launch an invasion of Europe. The British were proud to have stood alone, and were happy to remind the Americans of it, but knew deep down that defeating Germany depended on US manpower, industry and technology. Britain became a vast armed camp, where Americans and other Allied forces – Canadians, Poles, Czechs and Free French – trained and prepared alongside a rebuilt British Army for a return to the continent of Europe.

The D-Day invasion of June 1944 brought hopes for a swift victory, but the slowing down of the Allied advance in Europe later in the year meant the war would drag on into 1945.

The privations of wartime Britain continued, but plans for post-war reconstruction and social reform were already at an advanced stage. In May 1945 the population of Britain celebrated victory in Europe, and a general election saw the Labour Party sweep into power. Churchill, the great war leader, was not the man to lead the peace. The troops started coming home to resume civilian life. The election result reflected a mood among many that nothing should be the same again. Britain's war effort had seen vast sacrifices, upheavals and social changes. The people now looked towards their new government to use its wide-ranging powers of intervention to create what many hoped would be a fairer society for all.

PREVIOUS PAGE
A Spitfire Mk II of 72 Squadron over the north-east coast of Britain, April 1941. The Spitfire symbolised Britain's defiance in the air. After victory in the Battle of Britain, RAF Fighter Command went on the offensive, carrying out sweeps over the fringes of enemy-occupied Europe. The aim was to tie down Luftwaffe fighter squadrons. But RAF fighters lacked the range to penetrate far inland, and losses were heavy. 560 aircraft were lost in 1941 alone. The operations did little to prevent the Luftwaffe diverting the bulk of its effort to the east.

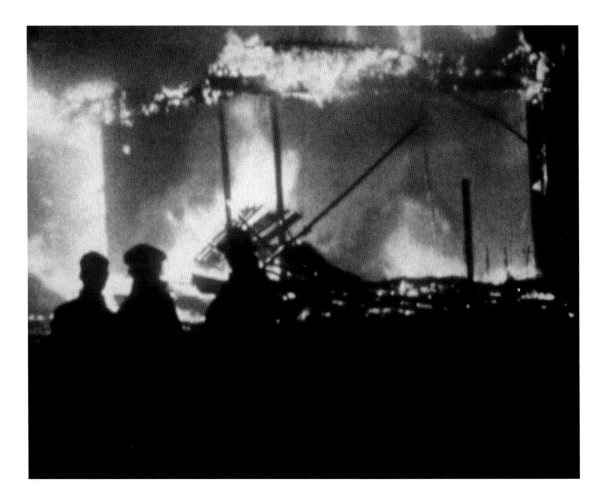

▲ A building on fire during an air raid on London, 1940.
The period of sustained bombing from 7 September 1940 to
11 May 1941, when 16 British cities were attacked and London
was bombed on 57 consecutive nights, became known as
the Blitz. London was by far the hardest hit, but Liverpool,
Birmingham, Glasgow and Plymouth also suffered several heavy
raids. London's worst night came on 29–30 December 1940
when Luftwaffe incendiaries razed the heart of the City to the
ground, in what was dubbed the 'Second Great Fire of London'.

**▶ An Air Raid Precautions (ARP) warden in Holborn,
London.** The ARP, later renamed the Civil Defence Service, was
set up before the war in response to the threat of aerial bombing.
The wardens' job of enforcing the blackout and checking on
people's living arrangements sometimes made them unpopular
– but if a house was reduced to rubble it was vital to know who
might be trapped inside. Most wardens were volunteers, with
regular daytime jobs. One in six were women. During raids the
wardens ensured people took shelter, reported on the severity
of bombing incidents and co-ordinated the work of stretcher
parties and rescue teams.

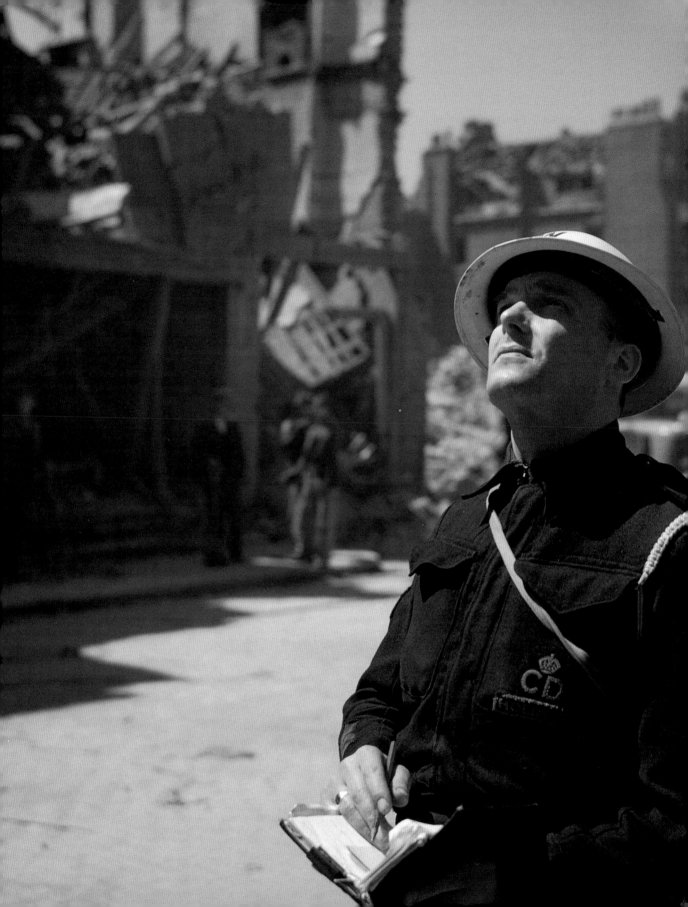

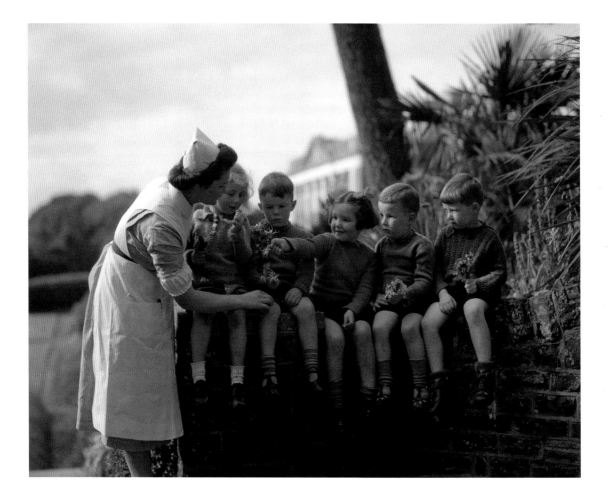

▲ **A nurse with young child evacuees in the gardens of Tapeley Park at Instow in North Devon, October 1942.** The house was used to accommodate 50 children evacuated from Plymouth after a series of Luftwaffe bombing attacks in March and April 1941. The port and naval docks at Devonport were the principal target, and were heavily damaged, but the city itself was devastated. In one of the worst episodes of the Blitz, 932 people were killed, and some 40,000 made homeless. In all, Plymouth suffered 59 separate bombing raids between 1940 and 1944, and a total of 1,172 civilians died.

▶ **Paratroopers photographed in front of a converted Whitley bomber that will take them aloft at RAF Netheravon, 2 October 1942.** German successes with parachute troops early in the war inspired Winston Churchill to demand that Britain raise its own airborne forces. The Parachute Regiment was created in 1942, and would eventually form 17 battalions — all volunteers. By 1943 two airborne divisions had been created, each comprising two brigades of parachute troops and an air-landing brigade with infantry carried into action by glider. British airborne forces fought in North Africa, Sicily, Italy, Greece and north-west Europe.

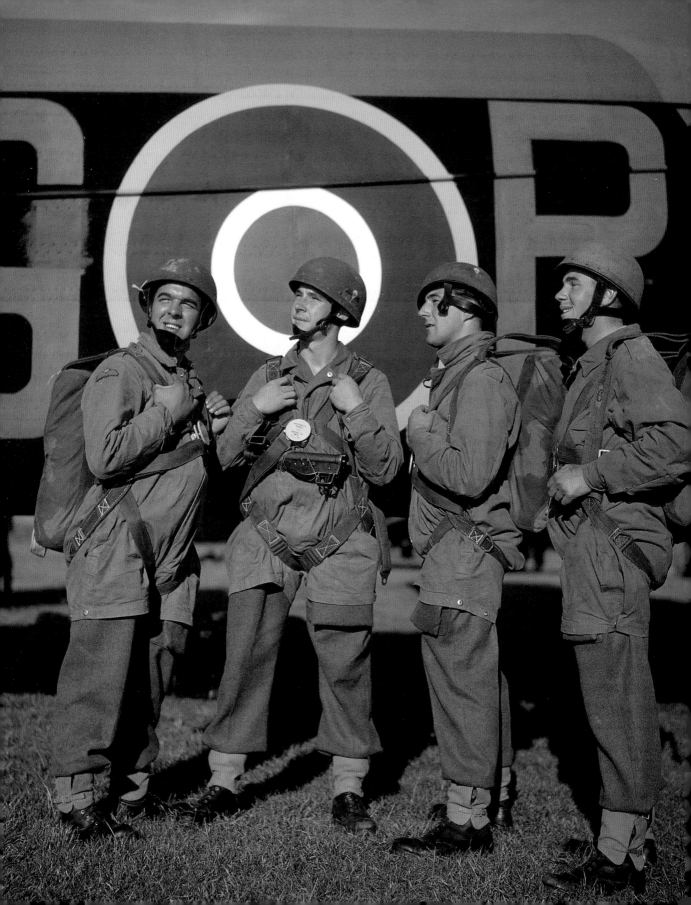

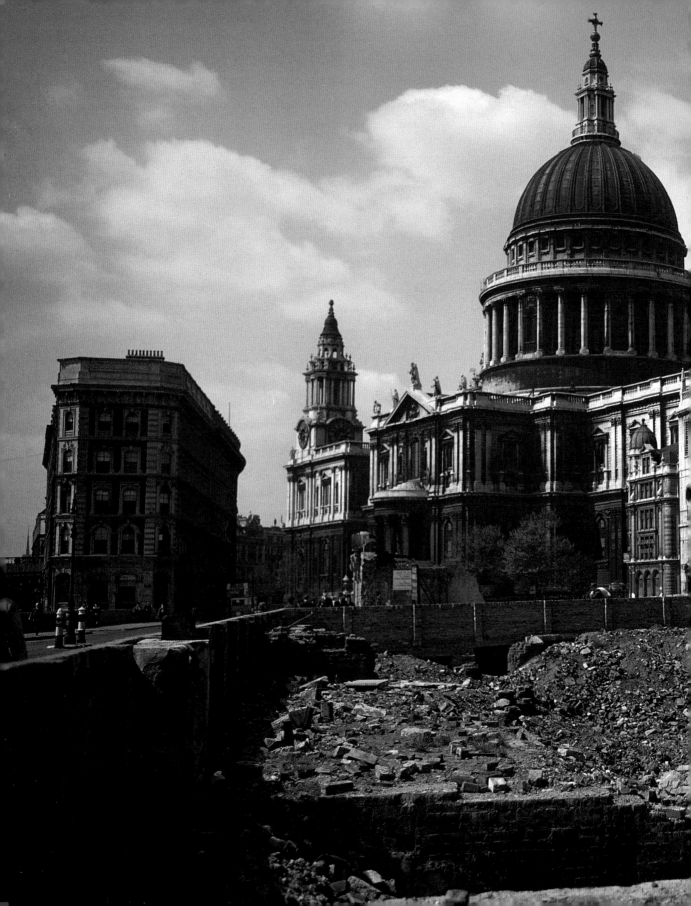

St Paul's Cathedral photographed from the remains of Cannon Street in 1944. Christopher Wren's masterpiece became a symbol of resistance to Londoners during the war. The building's almost miraculous survival was down to the heroic efforts of army bomb disposal teams and a well-organised group of fire-watchers set up by the Dean. Incendiaries caused the gravest threat, lodging themselves in the roof timbers of the dome. On the night of 29 December, as the City of London burned, one was tackled by fire-watchers crawling high above the nave. It fell to the floor and was extinguished.

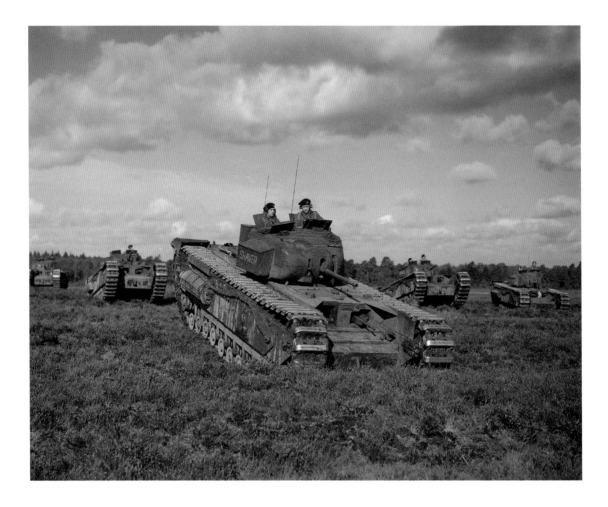

▲ **Churchill tanks of 43rd Battalion, Royal Tank Regiment (RTR) on manoeuvres near Sway in the New Forest, 21 October 1942.** The British Army initially distinguished between heavily armoured 'infantry tanks' such as the Churchill, intended to support frontal attacks, and lighter, faster 'cruiser tanks' for exploiting breakthroughs. Only later was the need for a dual purpose 'universal tank' properly recognised, by which time German tank design had stolen a march. Upgraded versions of the Churchill proved their worth in many battles, but 43 RTR stayed in the UK until after the war in Europe had ended, and never fired a shot in anger. *TR 219*

▶ **An Auxiliary Territorial Service (ATS) 'spotter' at a 3.7-inch anti-aircraft gun site on the outskirts of London, December 1942.** The ATS was established in September 1938, to allow women volunteers to serve in non-combatant roles alongside the military. In 1941 it was fully incorporated into the British armed forces. As the war progressed conscription was introduced, and roles available expanded from cooks, clerks and drivers to more varied and technical roles. The ATS reached a peak strength of 210,208 officers and other ranks in June 1943. A quarter served in Anti-Aircraft Command, operating searchlights, radar sets and rangefinders, although they were not allowed – in theory at least – to fire the guns themselves.

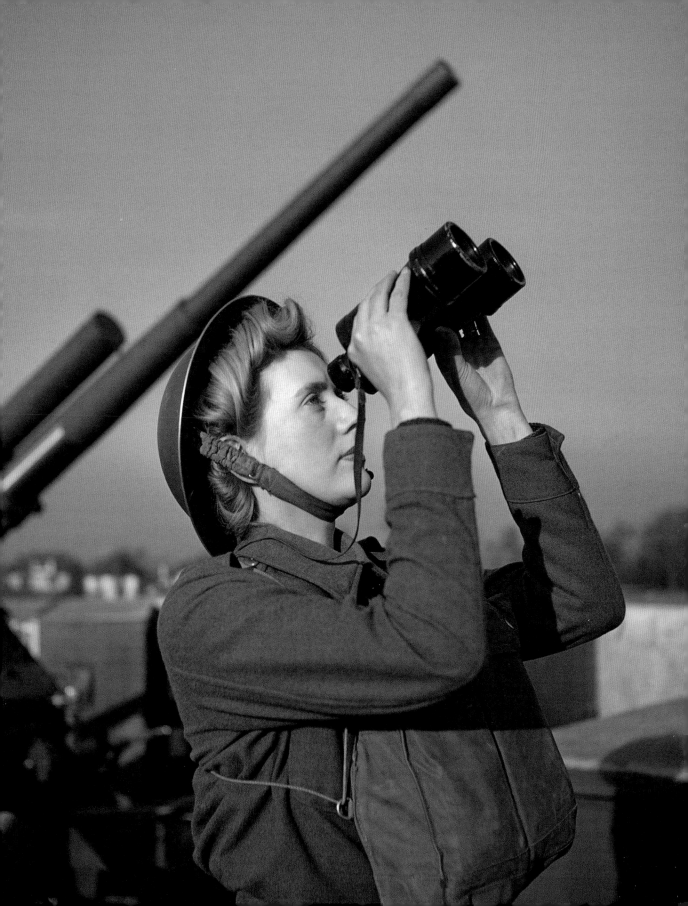

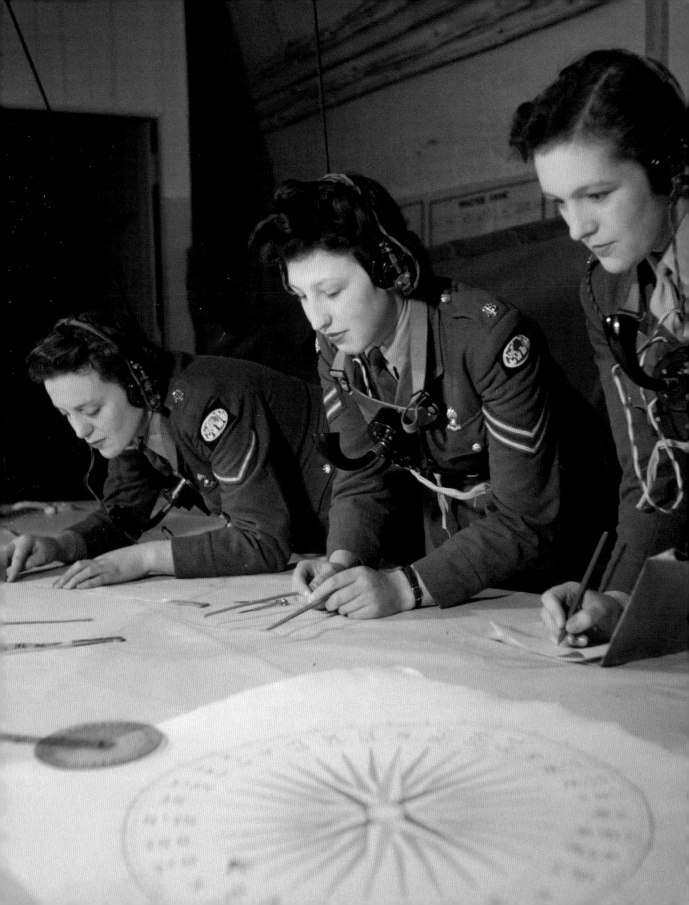

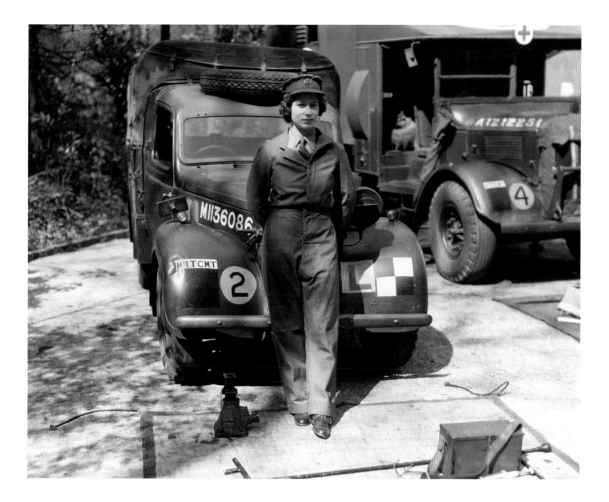

◀ **ATS plotters at work in Coastal Artillery headquarters at Dover, 21 December 1942.** They wear the 'oak, ash and thorn' badge of their parent formation, XII Corps, on their upper sleeves. The outset of war brought a massive increase in the number of coastal defence batteries, using stocks of old naval guns of various calibres brought out of storage. Once the threat of invasion had passed, the main task of coastal artillery was to close the Channel to enemy shipping. Several new batteries of heavy guns with sophisticated radar fire control systems were installed around Dover for this purpose.

▲ **Princess Elizabeth (the future Queen Elizabeth II) photographed during her service in the ATS at Camberley, April 1945.** Neither King George VI nor Queen Elizabeth wanted their daughters to be evacuated abroad, and so Princess Elizabeth spent most of the war at Windsor Castle with her younger sister, Margaret Rose. Elizabeth was keen to do her bit for the war effort, and was allowed to join the ATS in February 1945. As honorary Second Subaltern Elizabeth Alexandra Mary Windsor she learnt to drive and maintain vehicles such as the Austin 10 'Tilly' and Austin K2 ambulance seen in this photograph.

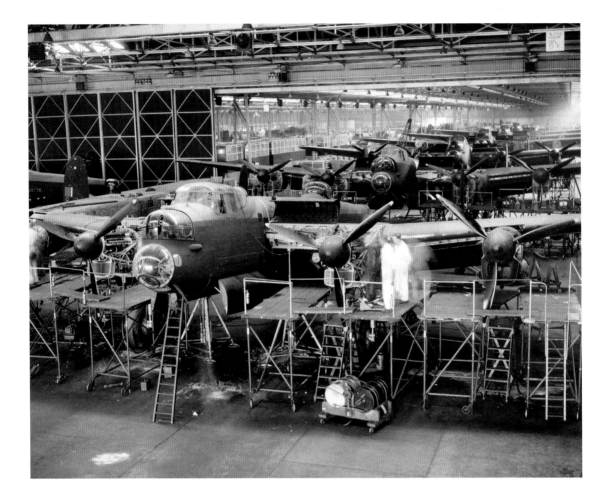

Avro Lancasters during final assembly at Woodford, near Manchester, 1943. This most famous of British bombers was built by six companies at various locations in the Midlands and northern England, and one in Canada. Lancaster production accelerated from a modest 23 in January 1942 to a wartime peak monthly output of 281 aircraft in September 1944. Half of all the 7,377 Lancasters built were manufactured at Avro's own plant at Chadderton near Oldham, then assembled and test-flown at Woodford aerodrome. Some 125,000 British aircraft were built during the Second World War, and over half of the workforce were women.

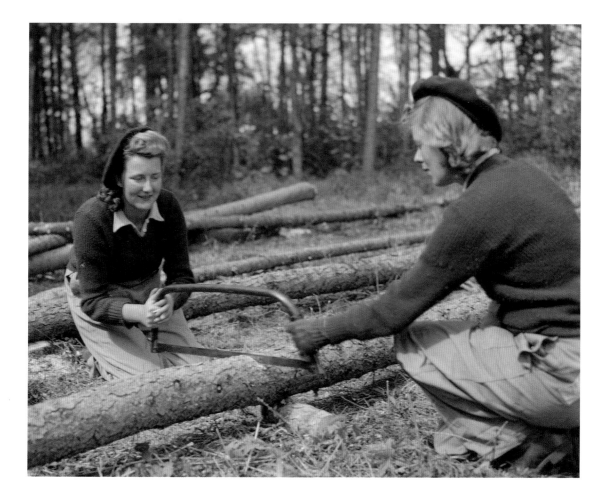

Two 'Lumber Jills' sawing larch trunks at the Women's Timber Corps training camp at Culford, near Bury St Edmunds in Suffolk, 1943. The Women's Timber Corps was part of the larger Women's Land Army, and was set up in March 1942 in response to a shortage of imported timber for such uses as telegraph poles and pit props. After a month-long course at Culford or other camps, the women were despatched to carry out forestry work throughout Britain. Duties included felling, crosscutting (as seen here), sawmill work and 'measuring' – assessing the amount of timber available in any given tree.

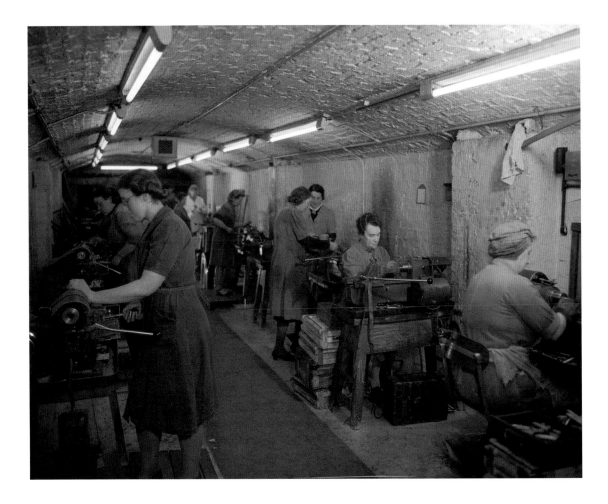

Women producing 20mm cannon shells in an underground munitions factory at New Brighton on the Wirral, Merseyside, 1945. The factory was located in underground tunnels and caverns originally used by smugglers and then re-discovered during the construction of the New Brighton Palace amusement arcade in the 1930s. At that time New Brighton was a popular seaside resort. During the war the tunnels were initially used as air raid shelters before housing the factory which employed more than 200 people.

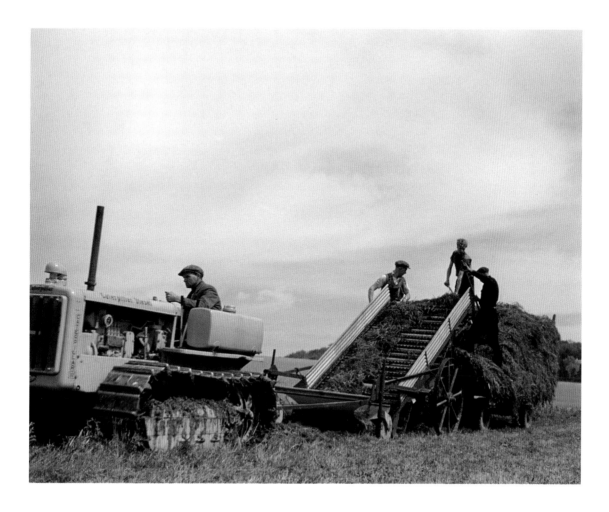

Grass is being cut to make silage for winter fodder at Eynsford in Kent, 1943. In 1939 Britain imported most of its food, and nearly all its livestock feed. Most farms were given over to pasture. The war forced a change to growing crops for human consumption — wheat, oats, barley and potatoes. Animal herds were reduced, which decreased the amount of meat available. Unproductive land was brought into cultivation, helped by the use of fertilisers and mechanisation (including the Fordson tractor seen here). By 1944 almost 7 million more acres were being farmed, and food production had risen by 90 per cent.

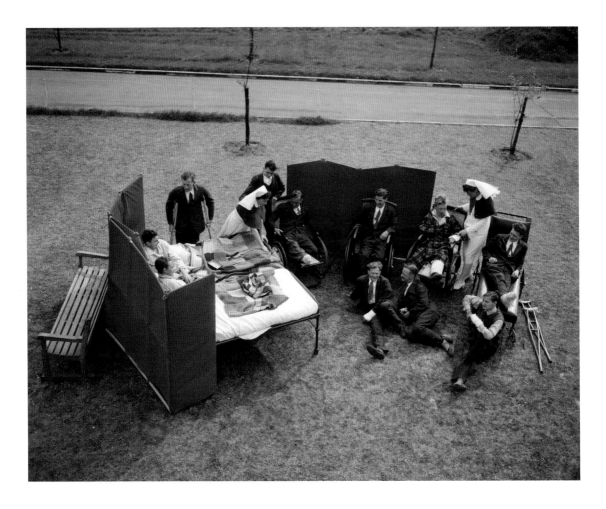

Nurses and convalescent aircrew at Princess Mary's Royal Air Force Hospital at Halton in Buckinghamshire, 27 August 1943. The men are wearing their 'hospital blues' – the uniform worn by wounded servicemen from the Crimean War to the 1960s. Halton hospital was opened in 1927, and treated some 20,000 RAF casualties during the Second World War. The RAF's nursing service was established in 1918, became a permanent organisation in 1921, and received official royal patronage – and the royal prefix – from Princess Mary, daughter of King George V, in 1923. Other RAF hospitals were located at Uxbridge, Ely and Wroughton.

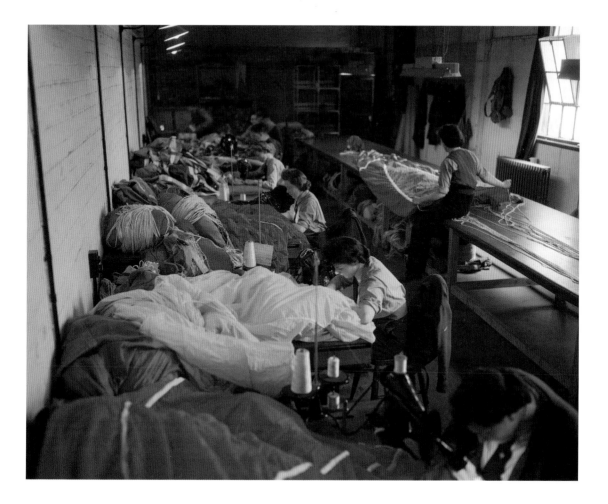

Members of the Women's Auxiliary Air Force (WAAF) preparing parachutes for use by British airborne forces in the invasion of Europe, 31 May 1944. Parachute canopies for supply canisters were colour coded; on D-Day red denoted weapons and ammunition, yellow was used for medical kit and blue for rations. The WAAF was created in June 1939, and initially comprised women transferred from the RAF companies of the ATS. The first conscripts were called up in April 1942. By the end of the war there were 182,000 women serving in the WAAF – 22 per cent of the RAF in Britain.

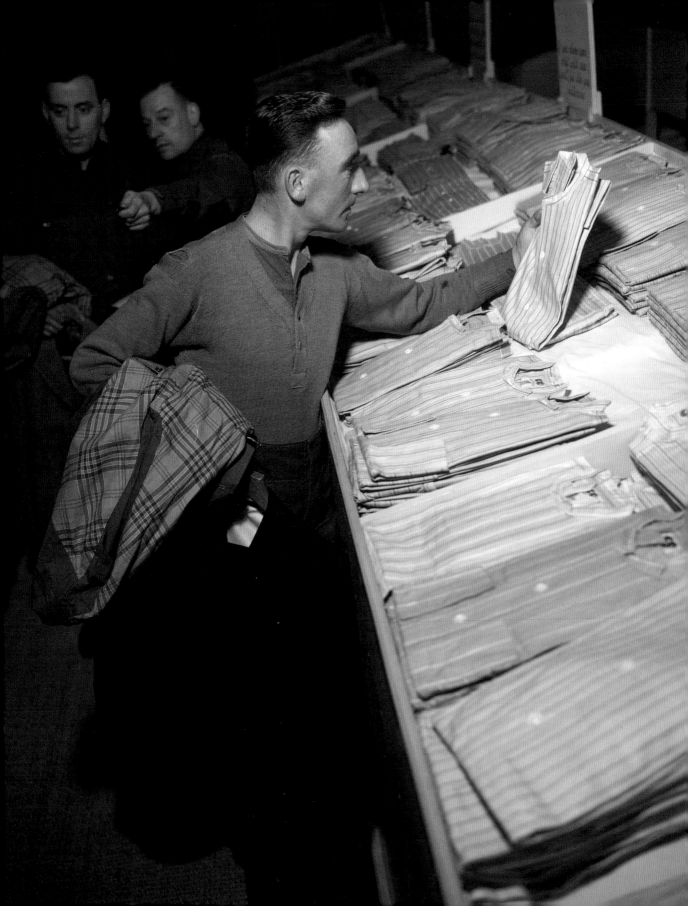

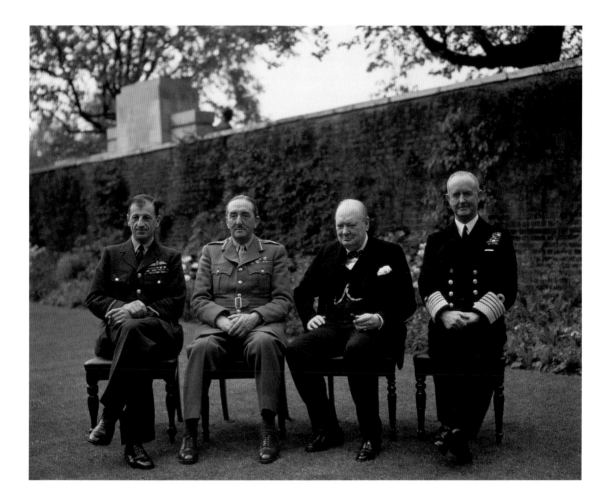

◀ **A soldier collects civilian clothing at a demobilisation centre, 1945.** At the war's end servicemen were entitled to a pinstripe three-piece suit or jacket and trousers, two shirts, a tie, shoes, raincoat and a hat or cap. The 'demob suits' were not universally popular, and in effect conferred a new uniformity on their wearers. Demobilisation of Britain's armed forces began on 18 June 1945, and by the end of 1946 over 4 million men and women had been released. The return to 'Civvy Street' could be a hard one, exacerbated by continuing shortages, rationing and the effects of bombing.

▲ **Winston Churchill photographed with his chiefs of staff in the garden of 10 Downing Street, 7 May 1945.** From left: Air Chief Marshal Sir Charles Portal; Field Marshal Sir Alan Brooke; Prime Minister Winston Churchill; Admiral Sir Andrew Cunningham. Early that morning the German High Command had surrendered unconditionally to the Western Allies in a ceremony at Reims in France. The press were aware but no formal announcement was made by Allied leaders. That evening, the BBC carried the momentous news. The following day – 8 May – would be 'Victory in Europe Day' and a national holiday.

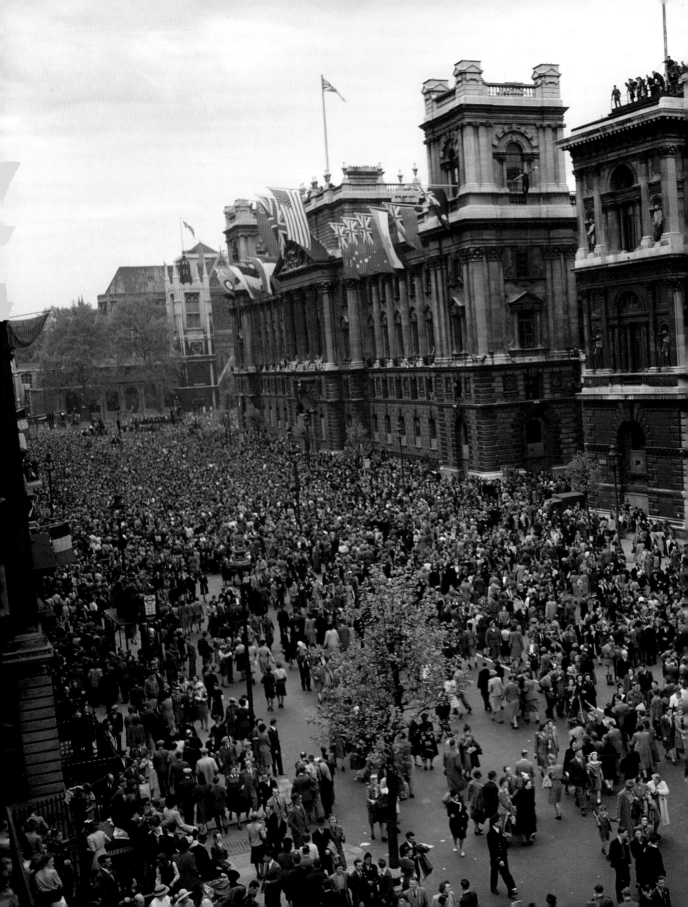

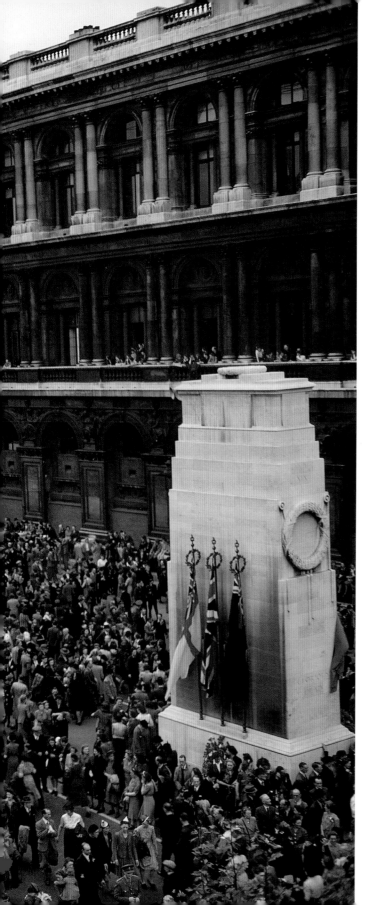

Crowds gather in Whitehall in London on VE Day, 8 May 1945. No official ceremonies for the occasion had been planned – instead people took to the streets in spontaneous celebration. That afternoon Winston Churchill addressed the nation and the world in a radio broadcast, declaring that the war in Europe was over and that 'we may allow ourselves a brief moment of rejoicing'. However, the fighting in the Far East and Pacific dragged on, and Victory over Japan would not be celebrated until 15 August 1945.

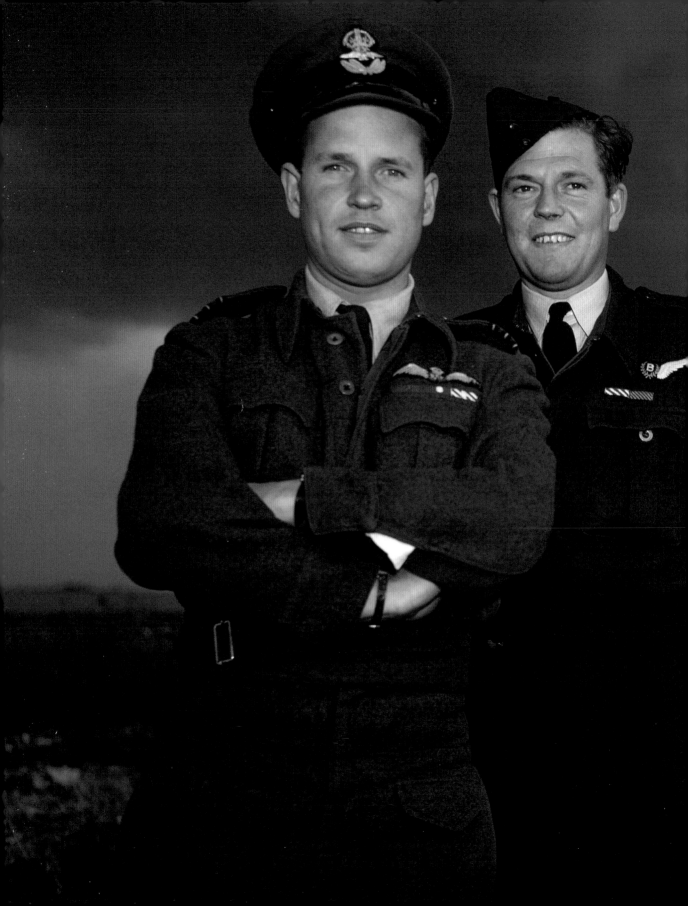

Chapter Three
STRIKING BACK

From the start, RAF Bomber Command expected to play a decisive role in the war. Though initially small and ill-equipped, the bomber force provided the only way for Britain to strike back directly at Nazi Germany. However, government policy initially forbade attacks on civilians or German territory. Instead, attacks were mounted against German warships, while other aircraft flew night raids over Germany, dropping propaganda leaflets instead of bombs.

In May 1940 Bomber Command finally embarked on a strategic offensive against German industry. The RAF had planned for daylight precision attacks on armaments factories, oil plants and the enemy's transport infrastructure. However, heavy losses had forced the bombers to operate in darkness, and they now had great difficulty finding and hitting their targets. Bombing policy had to be changed to reflect the new reality. Whole cities – and their working populations – were now targeted directly. The Blitz had eroded any public qualms about bombing German cities, and Hitler's invasion of the Soviet Union provided ample military and political reasons to maintain pressure on the Germans. The aim of the new 'area bombing' campaign was to destroy enemy morale, and bring German industry to its knees.

In 1942 RAF Bomber Command had new aircraft, including the Lancaster, and a new commander in Air Marshal Arthur Harris. Harris embraced the new policy, and was keen to prove that the bombers alone could win the war. Vast economic resources were poured into expanding the size and capability of his force, which until now had failed to do any meaningful damage. Technological advances promised significant improvements in navigation and bombing accuracy, but the aircraft remained vulnerable to enemy night fighters and anti-aircraft guns.

Harris achieved a major success with his 'Thousand Bomber' raid on Cologne in May 1942, but it was not until the spring of 1943 that his force was sufficiently prepared and equipped for what he described as the 'main offensive', which began with a sustained assault on the cities of the Ruhr-Rhineland industrial region. In July 1943 Hamburg was incinerated in a series of raids which killed 37,000 people.

By now the United States had joined in the aerial assault on Germany. The US Eighth Air Force was trained and equipped to operate in daylight, which gave an opportunity for 'round the clock' bombing. As part of this new combined bomber offensive, Allied military leaders aimed to shatter the Luftwaffe and pave the way for the invasion of Europe. To this end, American bombers flew missions against aircraft assembly plants and ball-bearing factories, but in October were forced to halt their deep penetration raids in the face of unsustainable losses.

Harris meanwhile continued with city attacks, and in November 1943 embarked on what he believed would be the decisive battle – an attempt to wreck Berlin and end the war. But Bomber Command's winter assault failed to destroy the city or the morale of its citizens. Over 1,000 RAF bombers were shot down. In February 1944 the Americans renewed their offensive against the Luftwaffe, this time benefitting from the presence of new long-range escort fighters, and the Germans soon lost control of their own airspace. The Americans now pressed for concentrated attacks on Germany's oil industry. But with Operation 'Overlord', the invasion of Europe, fast approaching, Supreme Allied Commander General Eisenhower took control of the bomber forces and directed them against rail communications in France in order to isolate the battlefield.

After the Allied victory in France the bomber forces were free again to concentrate on German targets. The US Fifteenth Air Force was now also adding its weight, flying from bases in Italy and able to reach targets in southern and eastern Europe. With a total of some 6,400 USAAF and RAF heavy bombers available, the offensive reached its zenith of power and destructiveness – three quarters of all bombs were dropped after D-Day. American attacks on oil plants in the summer had resulted in a dramatic fall in German fuel supplies, and these were stepped up with RAF support. Canals and railways continued to be attacked, and what was left of the Ruhr was pounded into ruins. Poor weather often forced US formations to bomb through cloud using radar – area bombing in all but name. Despite herculean attempts to repair and disperse production, German industry and its transport infrastructure was progressively disrupted. In 1945 came controversial raids targeting cities and towns hitherto spared attention. The bomber juggernaut was now so strong and technically capable that the destruction meted out was unprecedented. Dresden and Pforzheim were razed to the ground in cataclysmic firestorms, echoing that of Hamburg in 1943. The last city attacks took place days and sometimes hours before advancing Allied troops captured the ruins.

The Allied bomber offensive made a significant contribution to Allied victory. But its true worth was only apparent in the last year of the war, by which time Allied and Soviet ground forces had already made decisive territorial gains. Germany had been forced to divert huge resources of guns, aircraft and manpower from the fighting fronts to defend the Reich. Her population was never completely cowed by the bombing, and industrial output continued until the end. But enough damage was done, especially to fuel stocks and transportation, that military operations and planned weapon production had to be drastically cut back, with devastating consequences for Hitler's armies.

PREVIOUS PAGE

Wing Commander Guy Gibson (left) and members of his crew at RAF Scampton, 22 July 1943. Gibson led 617 Squadron's celebrated attack on the Ruhr dams in Germany in May of that year. Soon after this photo was taken, he embarked on a public relations tour around Canada and America. The other men in this photograph (from second left) – Fred 'Spam' Spafford, Robert Hutchison, George Deering and Harlo 'Terry' Taerum – died in September while flying with another pilot on a raid to breach the Dortmund-Ems canal. Gibson returned to operations in 1944, but was killed when his Mosquito crashed in the Netherlands.

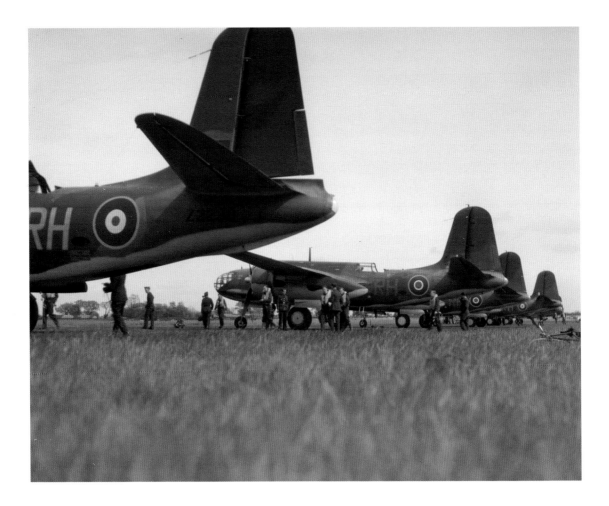

RAF aircrew and ground staff of 88 Squadron with their American-built Douglas Bostons at RAF Attlebridge, 21 May 1942. The squadron was part of 2 Group – the RAF's light bomber force which, from the early days of the war, had been undertaking low-level daylight bombing attacks over occupied France, Belgium and the Netherlands. Targets included enemy shipping, power stations, factories and airfields. Propaganda requirements were such that the RAF had to be seen to be striking back at the enemy by day as well as by night. The operations were however fraught with danger and losses were often heavy.

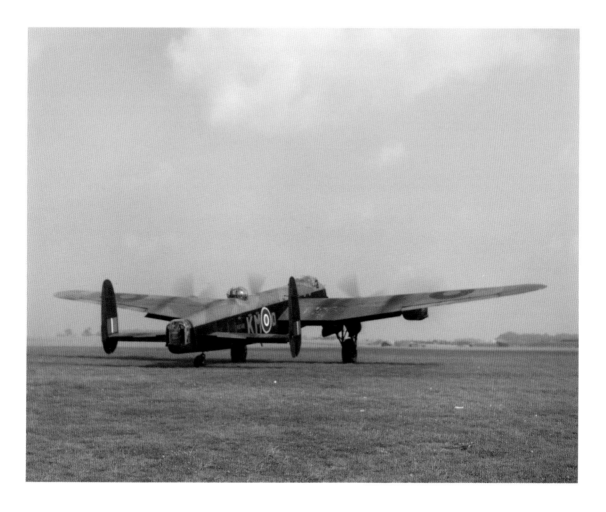

An Avro Lancaster of 44 Squadron taxies at RAF Waddington, October 1942. The Lancaster was first used on operations in March 1942, and went on to become the RAF's most important night bomber of the war. It could carry a prodigious weight of bombs, including the monstrous 22,000-lb 'Grand Slam'. By April 1945 Lancasters equipped 56 squadrons. They dropped 608,000 tons of bombs — two-thirds of Bomber Command's wartime total. But many of the aircraft had short lives, and of 7,377 built, 3,498 were shot down or destroyed in crashes.

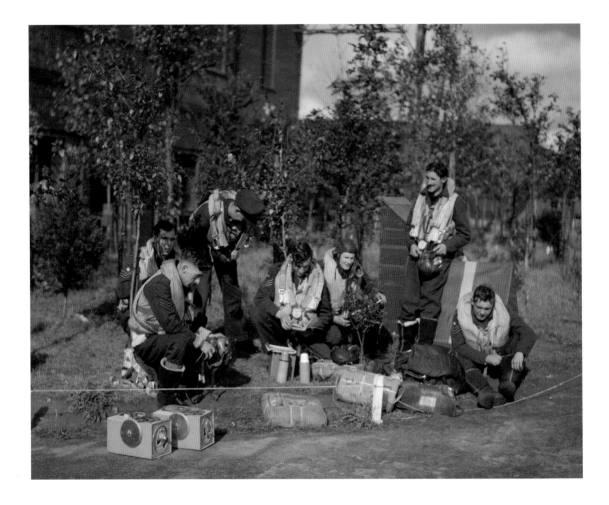

A Lancaster bomber crew at RAF Waddington, October 1942. All Bomber Command aircrew were volunteers, and a quarter were from Canada, Australia, New Zealand and other nations. They suffered the worst casualty rate of any group of Allied servicemen. Only a quarter would survive a normal tour of 30 operations. Of approximately 125,000 men who saw service, 55,220 were killed on 'ops' or in training. Two lesser members of the crew in this photo are the homing pigeons housed in their watertight yellow boxes. They could be used for emergency communication if the aircraft crash-landed or ditched at sea.

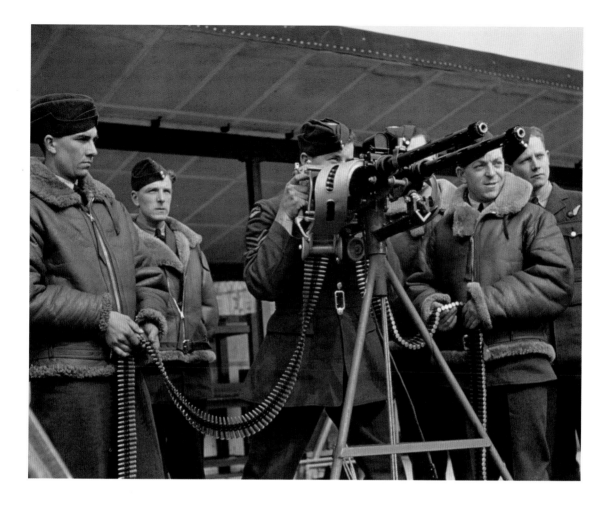

RAF air gunners practise with a pair of Browning .303-inch Mark II machine guns at a firing range in 1942. These weapons were standard fitment in the turrets of most British bombers, but lacked the range and hitting power of the 20mm cannon armament of opposing German fighters. In the night skies over Europe many gunners never fired their weapons in anger. Their chief role was to act as lookouts, ready to shout a warning to the pilot, who would then throw the aircraft into a series of violent evasive manoeuvres to try and evade their pursuer.

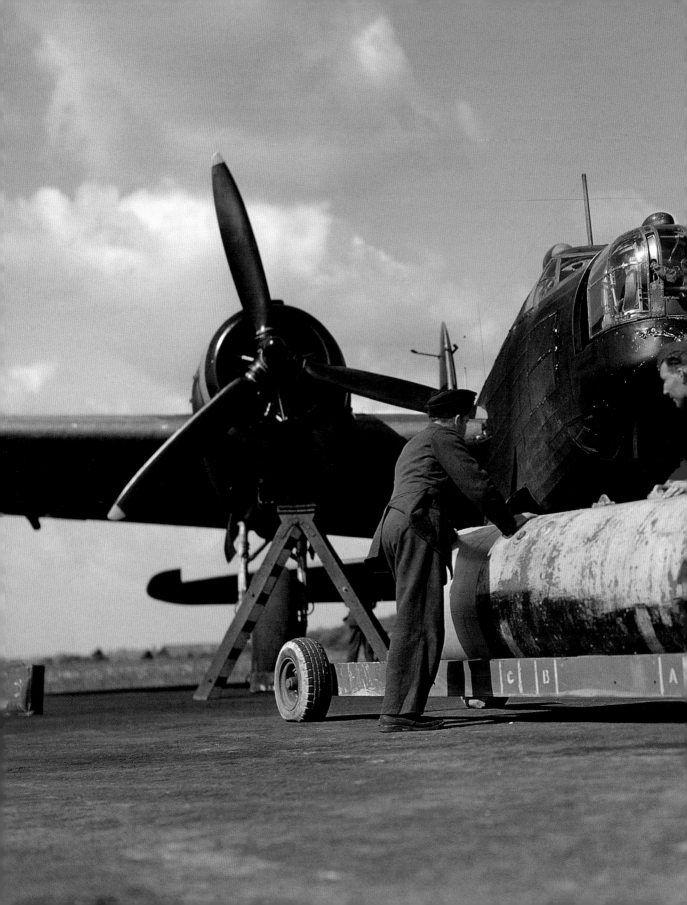

Armourers 'bombing up' a Vickers Wellington of 419 Squadron at RAF Mildenhall, 27 May 1942. The Wellington was the RAF's best bomber in 1939, and remained in front-line service in this role until October 1943. After costly daylight operations early in the war, the RAF switched to night bombing attacks. The darkness provided a measure of protection, but pin-point bombing accuracy was impossible. A policy of 'area bombing' against industrial cities was therefore adopted. The 4,000 lb high-capacity blast bomb or 'Cookie' seen in this photo was designed for maximum explosive effect. A combination of 'Cookies' and incendiaries became the standard offensive load on most raids.

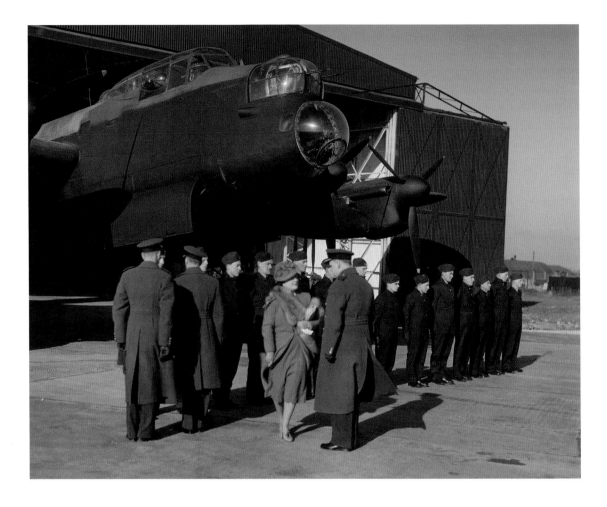

King George VI (second left) and Queen Elizabeth inspect a Lancaster bomber and ground staff of 156 Squadron at RAF Warboys, 10 February 1944. The squadron was part of RAF Bomber Command's Pathfinder Force, tasked with illuminating and marking aiming points using flares and coloured target indicators. Thanks to new radio navigation techniques and ground-scanning radar devices, bombing accuracy had improved dramatically from the early years of night operations, but RAF bomber losses were still severe. As an indication of this, 156 Squadron alone lost 31 crews between January and March 1944.

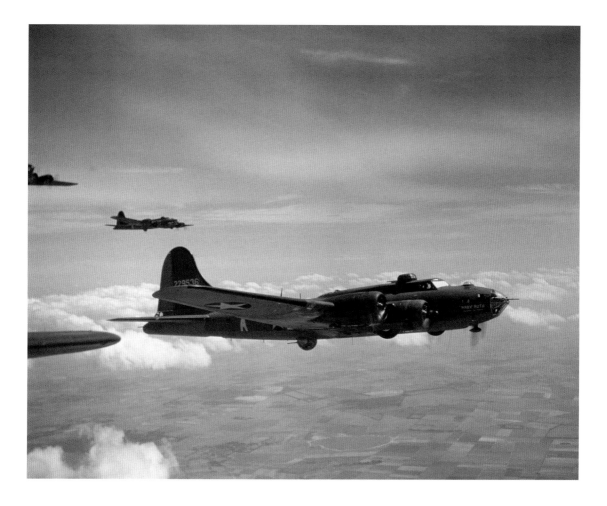

**B-17F Flying Fortress 'Mary Ruth – Memories of Mobile' flies alongside other aircraft of the
91st Bomb Group, Eighth Air Force, en route to attack the U-boat pens at Lorient, 17 May
1943.** Unlike RAF heavy bomber squadrons, the USAAF operated in daylight and crews were trained
to fly in close formation for mutual protection. Their aircraft were heavily armed with machine guns.
However, the concept of the self-defending bomber formation was soon discredited. Losses to
enemy fighters on unescorted missions threatened to derail the US bomber offensive. 'Mary Ruth'
was one of the casualties, shot down on 22 June on her 7th mission.

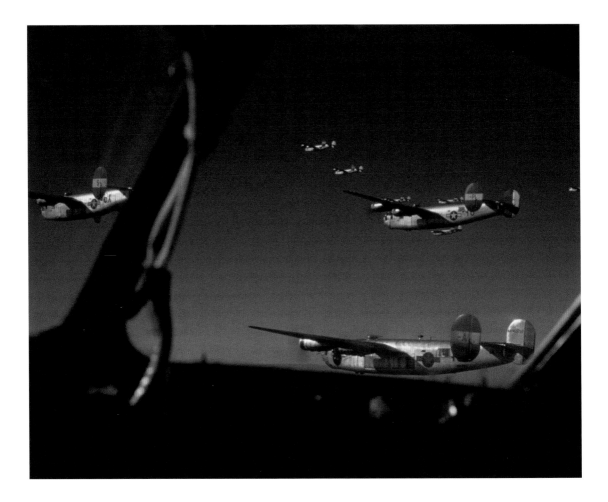

Pilot's eye view of a formation of B-24 Liberator bombers of the US 491st Bomb Group, 1944.
In February 1944 the USAAF launched Operation 'Argument', or 'Big Week' as it became known – a sustained attempt to finish off the 12 principal German aircraft assembly plants. The Americans now had a much larger force of bombers and escort fighters. In furious aerial battles the Luftwaffe lost 355 fighters and 150 pilots. The Messerschmitt plant at Regensburg was destroyed, but others were only damaged and production bounced back. 'Big Week' was a major turning point however, and marked the beginning of the end for the Luftwaffe in the west.

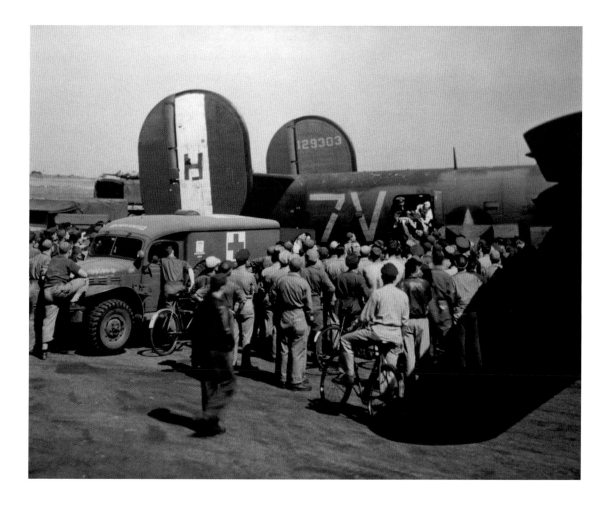

Personnel cluster around B-24H bomber 'Liberty Lib' of the 458th Bomb Group, Eighth Air Force, as wounded crewmen are extracted through the waist gun position to a waiting ambulance at Horsham St Faith, Norfolk, 25 August 1944. The aircraft had been on a mission to bomb the Dornier aircraft factory in Lübeck, and been hit several times by anti-aircraft fire ('flak'). Many of the crew were wounded. The Eighth Air Force suffered a total of 47,000 casualties in just two years and nine months of operations. Of these, 26,000 died.

A P-51D Mustang of the 361st Fighter Group during a bomber escort mission in 1944. The Mustang combined a superlative American aircraft design with the best British engine of the war, the Rolls-Royce Merlin. Fitted with drop-tanks, it had the range to stay with the bombers to the most distant targets, and from March 1944 rapidly established air superiority in German airspace. Given free rein to hunt and destroy their opponents on the ground as well as in the air, the US escort fighters made a more decisive contribution to Allied victory than bomber attacks on the German aircraft factories themselves.

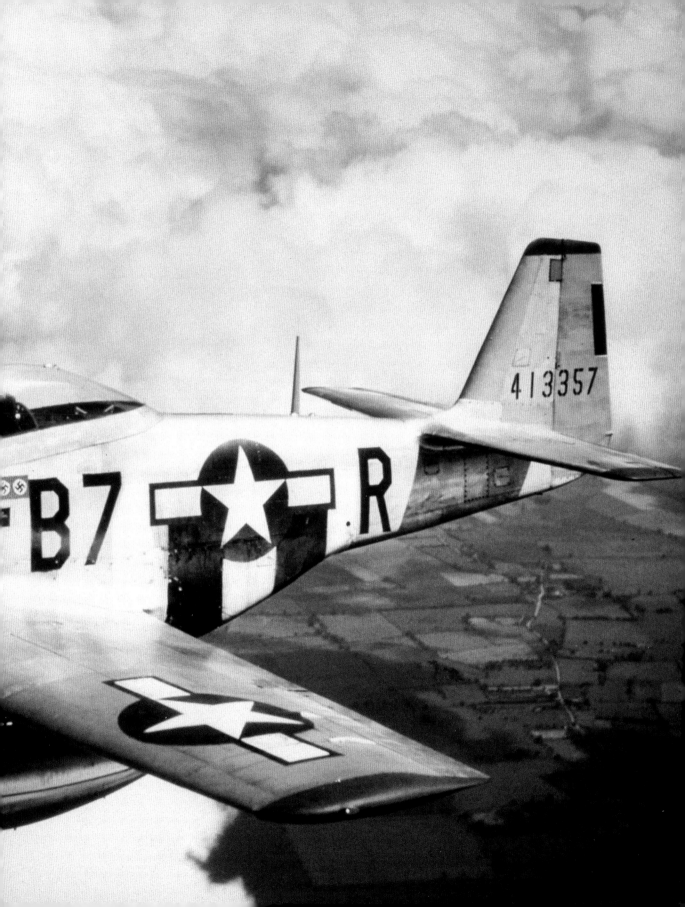

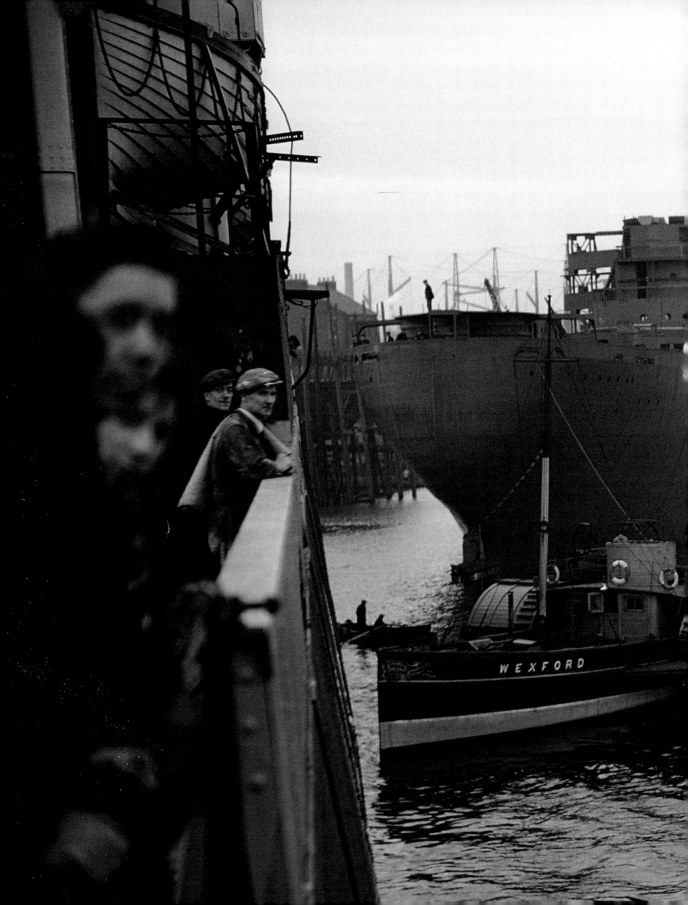

Chapter Four
WAR AT SEA

Throughout the Second World War Britain's overriding naval priority was to safeguard its imports of essential commodities and war supplies from its overseas dominions and the United States. In the wider sphere, the war at sea brought the demise of the battleship as the dominant naval weapon, and the rise of aircraft (whether carrier or shore based) as the primary instrument of control over the oceans. Combined operations, with naval, air and ground forces cooperating against a single military objective, took on ever greater significance as the war progressed.

The German Navy was ill-prepared for war in 1939. Plans for a massive expansion of its surface fleet had to be put on hold and the decision was made to concentrate on U-boat production. The U-boat arm under Admiral Karl Dönitz posed a significant threat to Britain's seaborne trade, and the Battle of the Atlantic became the pivotal campaign on which Allied fortunes depended. Britain's very survival depended on her links with America and Canada, and the success of future operations in the Mediterranean and Europe required safe passage for troops and supplies. Britain also sent aid to the Soviet Union, which led to major convoy battles in Arctic waters.

U-boat numbers were small at first, but they quickly made their mark. With few escorts available, Allied shipping losses mounted. The U-boats operated in 'wolf packs' and their disposition was controlled from shore by radio communications. This, however, made them vulnerable, and the interception and decryption of U-boat radio traffic was used to guide surface escorts and re-route convoys. America's entry into the war offered the U-boats fresh targets, but also ensured their ultimate downfall. US shipbuilding easily outpaced losses, and Dönitz never had enough boats to

tip the balance. In 1943 the battle reached a peak, but Allied countermeasures, especially long-range aircraft, prevailed.

Unlike the German U-boats far out in the Atlantic, British submarines fought their war mostly in shallow, dangerous waters near enemy coastlines, including Norway, the Adriatic and the Malacca Straits between Malaya and Sumatra in the Far East. Mines and enemy patrols were a constant hazard. The Mediterranean in particular was a rich hunting ground. Submarines based on Malta took a heavy toll of Axis ships bringing supplies to Rommel's forces in North Africa, but at great cost to themselves.

By comparison with Allied navies, Germany had few major warships and these were far less successful than the U-boats. The most famous, the battleship *Bismarck*, was sunk in May 1941 on its first operation to attack merchant shipping in the Atlantic. Its sister ship the *Tirpitz* survived longer, and remained a threat to the Arctic convoys until it was sunk in Norway by RAF Lancasters in 1944. Royal Navy warships were no less vulnerable to air attack. The Norwegian campaign, Dunkirk and the evacuation of troops from Greece and Crete all resulted in heavy losses. The Mediterranean was always a major focus for the Royal Navy, where it fought for control against the Italian Navy and escorted convoys to Alexandria and the besieged island of Malta. The aircraft carrier HMS *Ark Royal* was torpedoed on one such operation in November 1941.

Meanwhile, on the other side of the world, US naval power, so dramatically challenged by the Japanese attack on Pearl Harbor, expanded at a prodigious rate. The Japanese Empire had sought to cripple the US fleet and establish control over captured territories in the Pacific

and Far East. Here the decisive role of naval aircraft was proved beyond doubt when Japan's prime carrier force was destroyed at Midway in 1942. By 1944 powerful American naval task forces and their attendant supply trains were dominant. US Navy submarines embarked on a campaign against Japanese merchant shipping, effectively strangling the supply of raw materials that Japan desperately needed. In 1945 the British Pacific Fleet joined the Americans in the final stages of the Pacific campaign.

Amphibious warfare was a major feature of the Pacific War, and became increasingly important in the west too as Allied forces went on the offensive. Although not a new idea, the Second World War saw combined operations grow in size and sophistication. Substantial air cover was a prerequisite. The successful Allied invasion of North Africa in November 1942 was the first large-scale operation of this kind, and led to further landings in Sicily and Italy in 1943. Large naval armadas transported and escorted the assault troops and their follow-up waves, and provided the massive fire support needed to suppress enemy defences on a hostile shore. Most famous of all was Operation 'Overlord', the invasion of Normandy on 6 June 1944, which owed much of its success to the overpowering might of Allied naval forces.

PREVIOUS PAGE

Two steam paddle tugs, *Wexford* and *Corsair*, at work among the hulls of newly-launched cargo ships at the Harland & Wolff shipyard in Belfast, 1943. British yards produced 7 million tons of merchant shipping during the war, a figure dwarfed by the 53 million tons produced in the United States. In December 1940, with ships being sunk faster than they could be built, Britain ordered 60 new vessels from America. President Roosevelt launched the 'Emergency Shipbuilding Program' in January 1941, which would eventually result in over 5,700 standardised merchant ships of various types, including the famous 'Liberty Ships'.

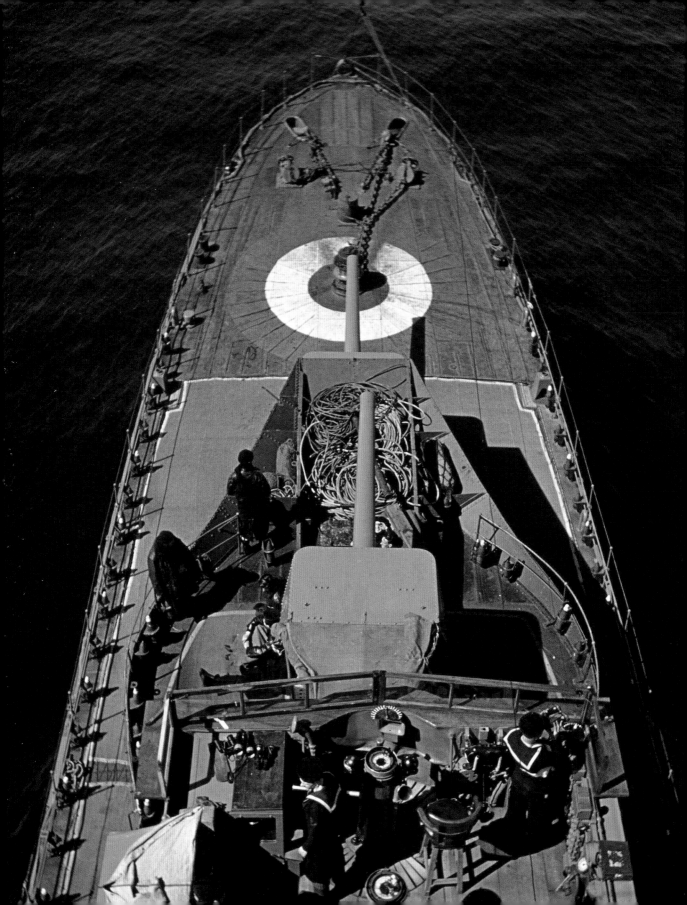

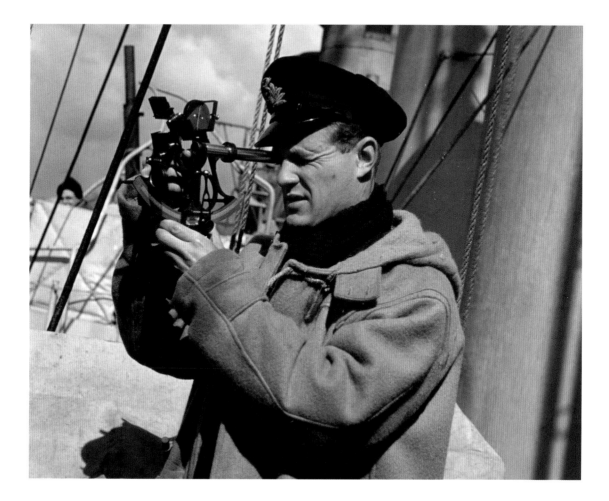

◀ **A view of the bridge and forward armament of a Royal Navy destroyer, 1942.** The struggle to protect Britain's lifeline across the Atlantic became one of the key campaigns of the war, but the Royal Navy was initially unprepared. Underwater sound location (ASDIC) was less effective than anticipated, as U-boats tended to attack on the surface at night. Radar became a vital requirement, and new anti-submarine tactics and weapons had to be developed. Destroyers were always in short supply, and the crucial task of escorting merchant convoys fell to specialised corvettes, sloops and frigates.

▲ **A Royal Navy officer uses a sextant aboard a Town-class destroyer, 1942.** This ship was one of 50 mothballed American First World War destroyers provided to Britain as a result of the 'destroyers for bases' agreement of September 1940. In exchange, the United States was granted leases to establish air and naval bases in the British West Indies, Newfoundland and Bermuda. The ships themselves were in poor condition, and of limited usefulness. The most famous was HMS *Campbeltown*, which was used to ram and destroy the dry dock at St Nazaire during a daring raid in March 1942.

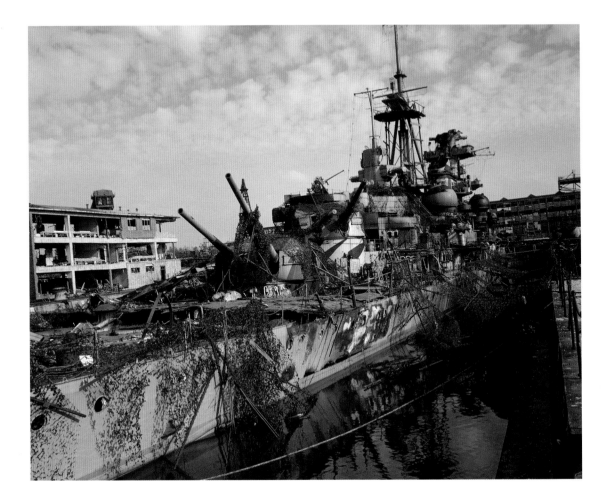

▲ **The German heavy cruiser** *Admiral Hipper* **at Kiel, May 1945.** Despite attempts at camouflage, the ship had been badly damaged in an RAF bombing raid. Hitler's grandiose plans for a navy to rival that of Britain's, were never fulfilled, and in 1939 priority was given to U-boat production. By the end of 1943, most major German warships had either been sunk or were bottled up in ports. At the war's end, the remaining ships of the *Kriegsmarine* helped evacuate German civilians fleeing from East Prussia and Pomerania in the face of the Soviet advance.

▶ **A Grumman Martlet fighter prepares to take off from HMS** *Formidable* **during Operation 'Torch' – the Allied landings in Vichy French North Africa, November 1942.** This was the first major Allied amphibious assault of the war. It opened up a new front from which to attack the German Army in Africa, now retreating westwards after defeat at El Alamein in Egypt. *Formidable* provided air support during the operation, and later took part in the Allied invasion of Sicily. The Martlet (also known as the Wildcat) was one of several American-built aircraft employed by the Fleet Air Arm in place of inferior home-grown designs.

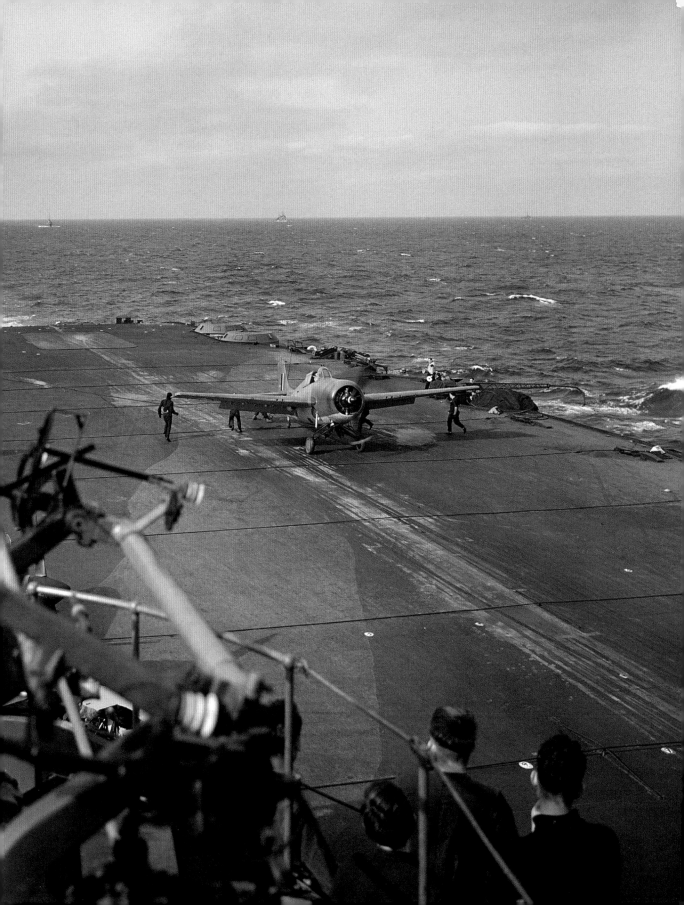

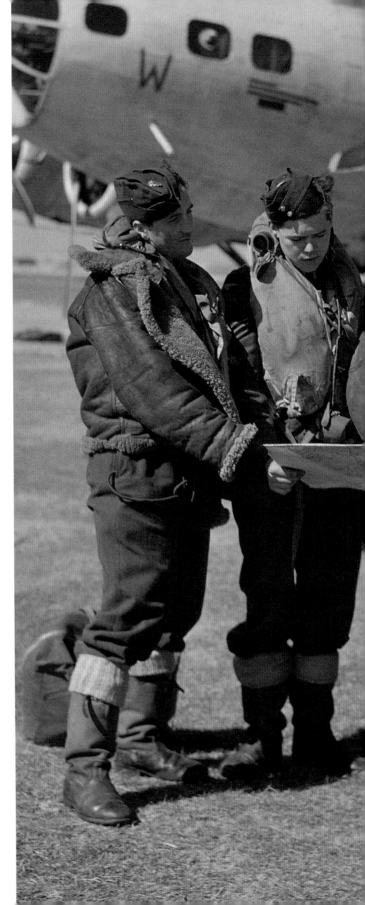

Aircrew pose in front of a Boeing Fortress Mk II of 220 Squadron, RAF Coastal Command, on the island of Benbecula in the Outer Hebrides, May 1943. Long-range aircraft played a vital role in winning the Battle of the Atlantic. Based in Newfoundland, Iceland, and the western fringes of the UK, they extended anti-submarine operations out into the so-called 'Mid-Atlantic Gap', the area of ocean where U-boats had been operating beyond Allied air cover. May 1943 was a turning point. 41 U-boats were sunk by Allied aircraft and naval forces. The U-boats withdrew from the North Atlantic, and were never a significant threat again.

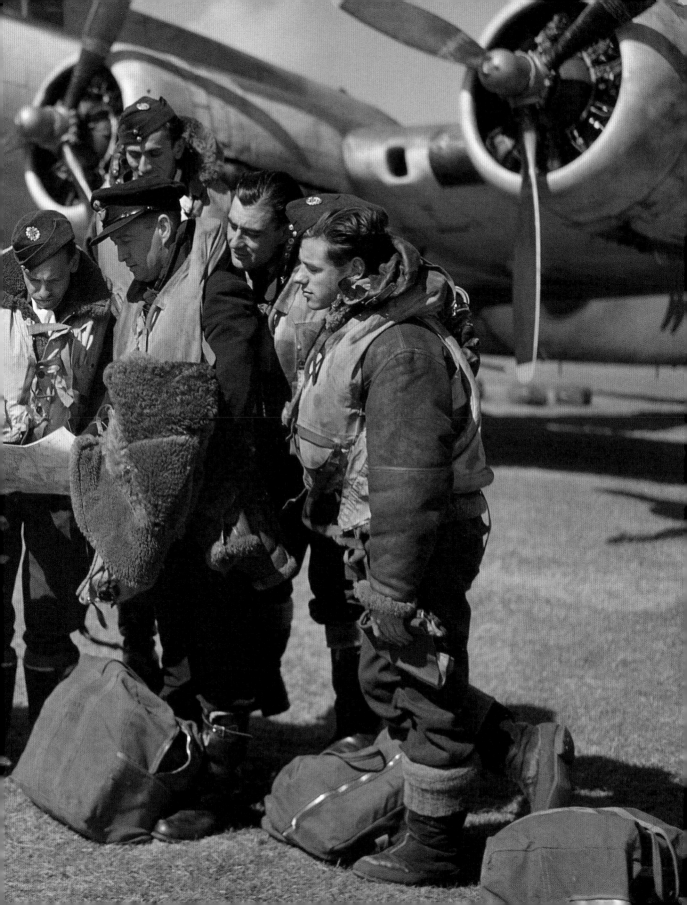

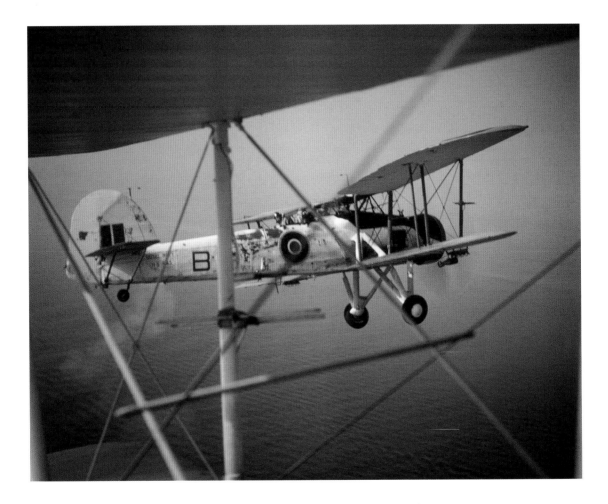

A Fairey Swordfish torpedo bomber of the Fleet Air Arm. The 'Stringbag' was one of the more successful British naval aircraft, despite its antiquated appearance. Until 1937 the RAF, not the Royal Navy, was responsible for naval aviation, and afforded it scant resources. As a result the Fleet Air Arm began the war with out-of-date aircraft. Their replacements were long in gestation, and effectively obsolete when they entered service. The Swordfish gained fame after its use in the torpedo attack on the Italian fleet at Taranto in November 1940. It soldiered on in service until 1945.

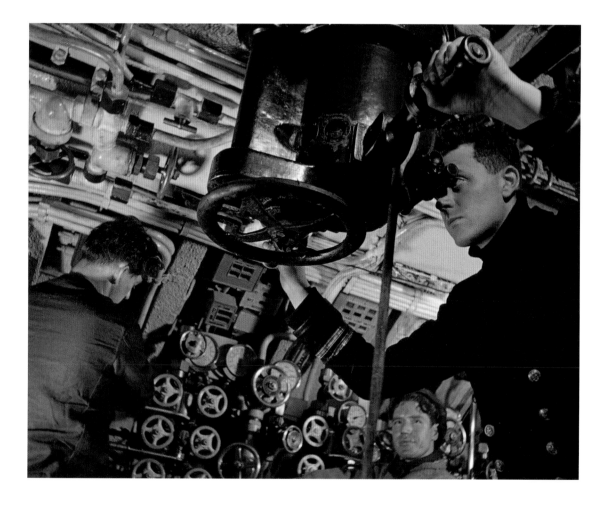

First Lieutenant Robert Bulkeley at the forward periscope of the Royal Navy T-class submarine HMS _Tribune_ at Holy Loch in Scotland, 1942. This was one of a sequence of publicity photos taken aboard the submarine during the making of the wartime propaganda film _Close Quarters_, produced by the Crown Film Unit and released in 1943. Bulkeley went on to command the submarine HMS _Statesman_ in the Far East. Over the course of nine patrols he torpedoed a Japanese tanker, and sank another 44 enemy ships and landing craft by gunfire or boarding.

The King George V-class battleship HMS *Howe* passing through the Suez Canal on her way to the Far East, 14 July 1944. Britain was keen to play a role in the final naval campaigns of the Pacific War, so that British forces might be involved in liberating former colonial bases such as Hong Kong. The British Pacific Fleet eventually comprised four battleships, six large aircraft carriers and many other vessels, but played only a subsidiary role. In March 1945 its battleships and carrier aircraft were tasked to bombard Japanese Kamikaze airfields in the Sakishima Islands while US forces landed on nearby Okinawa.

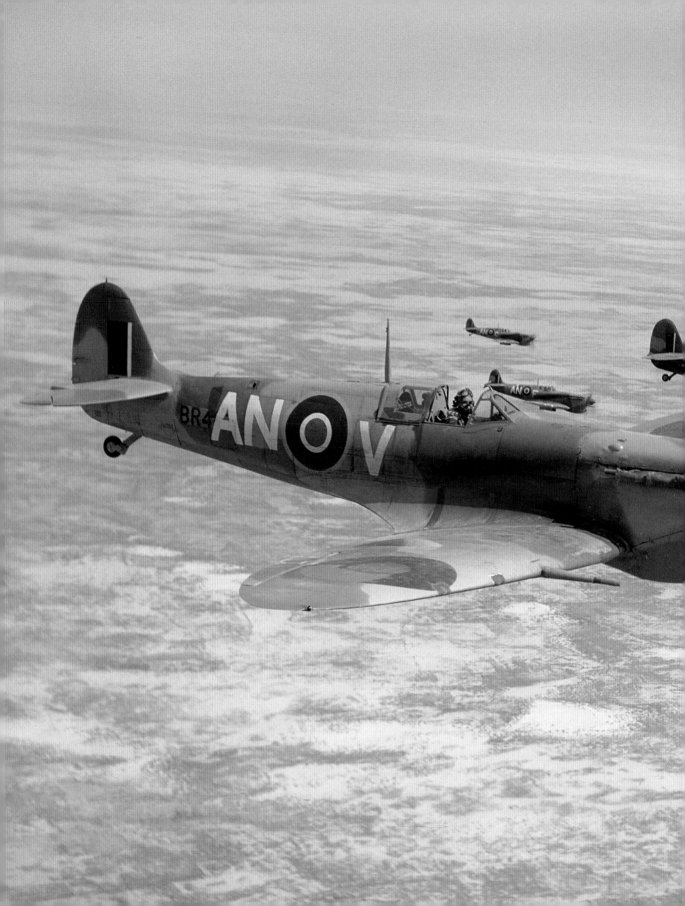

Chapter Five

FORCES OVERSEAS

For much of the Second World War Britain's military strategy focused on North Africa and the Mediterranean. The catalyst was Italian dictator Benito Mussolini's declaration of war in June 1940. Mussolini was keen to share in Germany's apparent victory, and his expansionist aims threatened British possessions in Egypt and East Africa. He also boasted that he would turn the Mediterranean into an 'Italian Lake'. The Royal Navy quickly proved its superiority, but Britain's position was still precarious, especially after the elimination of the French fleet and the arrival of Luftwaffe units in Sicily. The threat of Axis air attacks effectively cut Britain's links to the Middle East and India via the Suez Canal. Shipping was forced to go the long way round, via the Cape of Good Hope in South Africa.

In September 1940 Mussolini instructed his generals to advance into Egypt, but his army suffered a crushing defeat at the hands of the numerically smaller British Western Desert Force. The Italians were pushed back 500 miles into Libya, and 130,000 men were taken prisoner. Mussolini's ambitions were also thwarted in East Africa when in the spring of 1941 his forces were ousted from Ethiopia, Eritrea and Italian Somaliland. Britain hoped for a similar morale-boosting victory when it sent an expeditionary force to Greece in March 1941 to oppose the German invasion, but Hitler's forces were more serious opposition. They quickly gained the upper hand and British troops were evacuated at the end of April. Many were taken to Crete, which the Germans then attacked and captured in a daring but costly airborne operation.

The war in North Africa assumed a greater importance during 1941. Hitler despatched the Afrika Korps to Libya under the leadership of General Erwin Rommel to shore up his Italian

ally. Despite early success with an offensive which pushed the British back into western Egypt, Rommel's forces failed to take the vital port of Tobruk and in December 1941 had no choice but to retreat to Libya.

The see-saw campaign in North Africa continued into 1942. In June Rommel attacked again, and this time took Tobruk. From here he lunged at Egypt, but the British Eighth Army had built up their forces and under the leadership of a new commander, General Bernard Montgomery, won a decisive victory at El Alamein in November 1942. German and Italian forces were pushed into a retreat westwards, and this time there would be no return. In the same month American and British troops landed in Algeria and Morocco during Operation 'Torch'. The Axis forces, sandwiched between two armies, had no choice but to surrender in Tunisia in May 1943.

By this stage there was disagreement in the Allied camp over the future direction of the war. The British wanted to continue operations in the Mediterranean, but the Americans were keen to put all available resources into Operation 'Overlord', the planned invasion of north-west Europe. The US eventually agreed to an invasion of Sicily in July 1943, and then mainland Italy in September, as a way of pinning down and degrading German forces, but insisted that priority for resources should go to the forthcoming Normandy landings. In July, as the Allies advanced across Sicily, a discredited Mussolini was deposed by his own government and arrested. In September Italy sued for peace, but there was to be no rejoicing. Hitler ordered his troops to quickly take over and prepare for the Allied landings. The Italian campaign would drag on for the rest of the war, as troops from Britain, America and a host of Allied nations clawed their way

northwards up the country's mountainous spine, overcoming a succession of fixed defensive lines in costly battles.

From December 1941 Britain fought a long and sometimes 'forgotten' war in the Far East. In early 1942 the Japanese conquered Malaya and Singapore, alongside attacks on American and Dutch possessions. By May they had pushed British forces out of Burma and were on the borders of India. After an ignominious retreat, a reconstituted British Army went on the offensive in 1943. Early attacks on the coastal Arakan region failed, but a Japanese assault on India itself launched in March 1944 was decisively beaten at Imphal and Kohima. The British Fourteenth Army under General William 'Bill' Slim then embarked on a successful counteroffensive to reclaim Burma. The ensuing campaign proved to be one of Britain's greatest feats of arms during the Second World War. British, Indian and African troops had to contend with an oppressive climate, difficult terrain and tropical diseases, as well as a tenacious enemy. Throughout, the RAF played an important role dropping supplies from the air and evacuating the wounded. The Americans were involved in the Burma campaign too, principally to keep open supply routes to China. But their attention was focused on the conflict in the Pacific, where the Japanese were contained and defeated in a bloody island-hopping war. In August 1945 British forces reoccupied their old bases in the Far East, but the world had now changed. Victory over Japan precipitated a gradual retreat from Empire.

PREVIOUS PAGE

Spitfire Mk Vs of 417 Squadron, Royal Canadian Air Force, flying over Tunisia on an escort mission, April 1943. The first Spitfires were despatched to Egypt in June 1942, where the RAF's Hurricanes and Kittyhawks were outclassed by the new Luftwaffe Messerschmitt BF109F. In February 1943 417 Squadron began flying operations with the Western Desert Air Force (WDAF) in support of the victorious Eighth Army, advancing westwards in pursuit of the retreating Afrika Korps. As with other Spitfire squadrons, their principal task was to act as 'top cover' for ground attack aircraft.

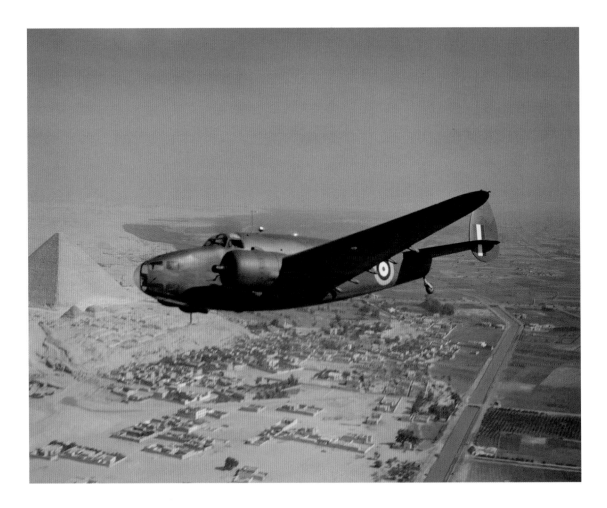

A Hudson Mk VI of the RAF's Air Headquarters Middle East Communication Flight, flying over Egypt's most famous landmark, the Great Pyramid of Giza, in the summer of 1942. The RAF had a sizeable presence in the strategically important Nile Delta region of Egypt, with some 15 airfields covering Cairo, the Royal Navy base at Alexandria and the Suez Canal. As well as the Western Desert and eastern Mediterranean, RAF Middle East Command was also responsible for air operations in East Africa, Palestine, Iraq and Persia. The Lockheed Hudson was another American-built aircraft — a former airliner, pressed into service by the RAF for transport and reconnaissance duties.

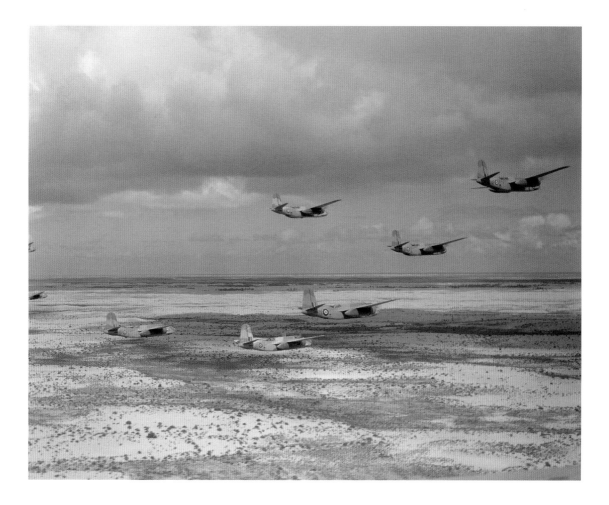

A formation of Douglas Boston light bombers of 24 Squadron, South African Air Force, flying low over the arid Tunisian desert, March 1943. They were part of the Western Desert Air Force (WDAF), which had evolved into a mobile, highly effective tactical air force, despite operating in the harshest of conditions. By the Second Battle of El Alamein in November 1942 the WDAF comprised 29 British, Australian and South African squadrons, and had achieved aerial superiority over the Luftwaffe. During the final battles in Tunisia, they were joined by many USAAF squadrons in a joint Allied organisation called Northwest African Tactical Air Force.

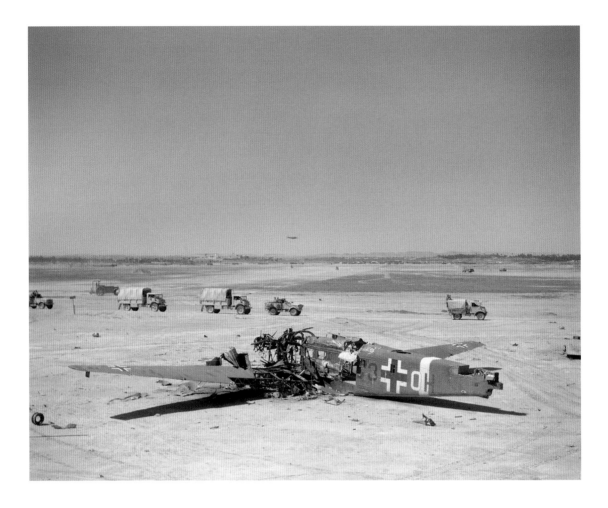

British vehicles passing the wreck of a German Junkers Ju 52 aircraft at Gabès airfield in Tunisia, March 1943. It was envisaged that the Allied landings in Vichy French Algeria and Morocco in November 1942 would be followed by a quick advance by the British First Army along the coast towards Tunis, but Hitler sent in reinforcements and his forces in the north held their ground. In the south, the retreating Germans and Italians dug in behind the defences of the Mareth Line. In March 1943, the Eighth Army broke through, forcing an Axis retreat.

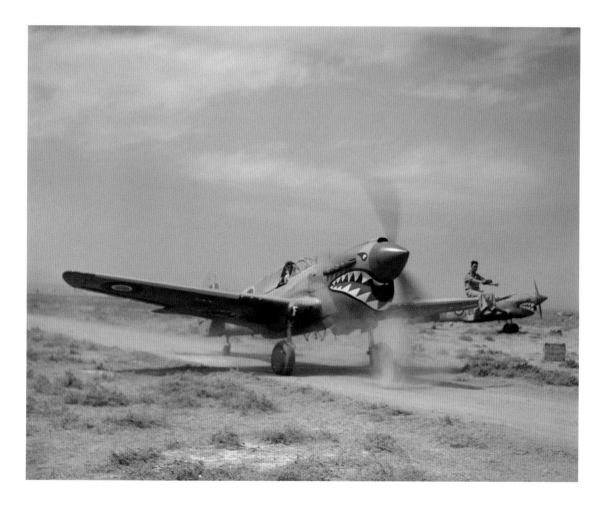

A Kittyhawk Mk III of 112 Squadron, taxiing at Medenine in southern Tunisia, May 1943.
The airman on the wing is directing the pilot, whose view ahead is blocked by his aircraft's nose.
The rugged, American-built Curtiss P-40, known variously to the RAF as the Tomahawk and
Kittyhawk, came to symbolise the WDAF – and none more so than those of 112 Squadron, which
were decorated with a distinctive 'shark mouth'. Early versions of the P-40 lacked high altitude
performance, which made them vulnerable to the latest Luftwaffe fighters, but the Kittyhawk went
on to become an effective ground attack aircraft.

▲ **A Crusader Mk III crew of the 16th/5th Lancers, 6th Armoured Division, clean the barrel of their tank's 6-pdr gun at El Aroussa in Tunisia, 3 May 1943.** In February, 6th Armoured had helped block the German 10th Panzer Division advancing after defeating the Americans at the Kasserine Pass in the Atlas Mountains. The division was then in the forefront of the final British assault on Tunis, which fell on 7 May. Though German resistance had been tenacious, the outcome of the Tunisian campaign was never in doubt. Some 238,000 Axis troops surrendered – a defeat comparable to the recent disaster at Stalingrad.

▶ **Local boys enjoy a ride on a Sherman tank of the 3rd County of London Yeomanry (Sharpshooters) in the village of Milo, near Catania, Sicily, 15 August 1943.** The invasion of Sicily, which began on 10 July 1943, was the next step in the Allies' Mediterranean strategy, but was flawed by poor Anglo-American cooperation. The Germans staged a masterful defence of the island, and managed to evacuate most of their troops to Italy before Allied units finally entered Messina on 16 August. By this date the reliable American-built Sherman had become the standard Allied tank, equipping most British and American armoured regiments.

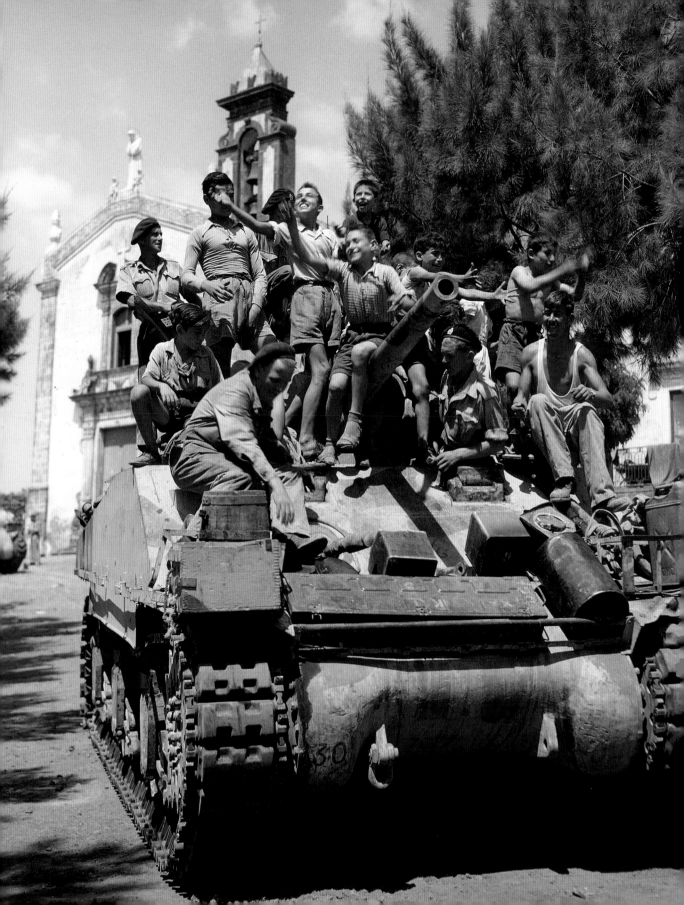

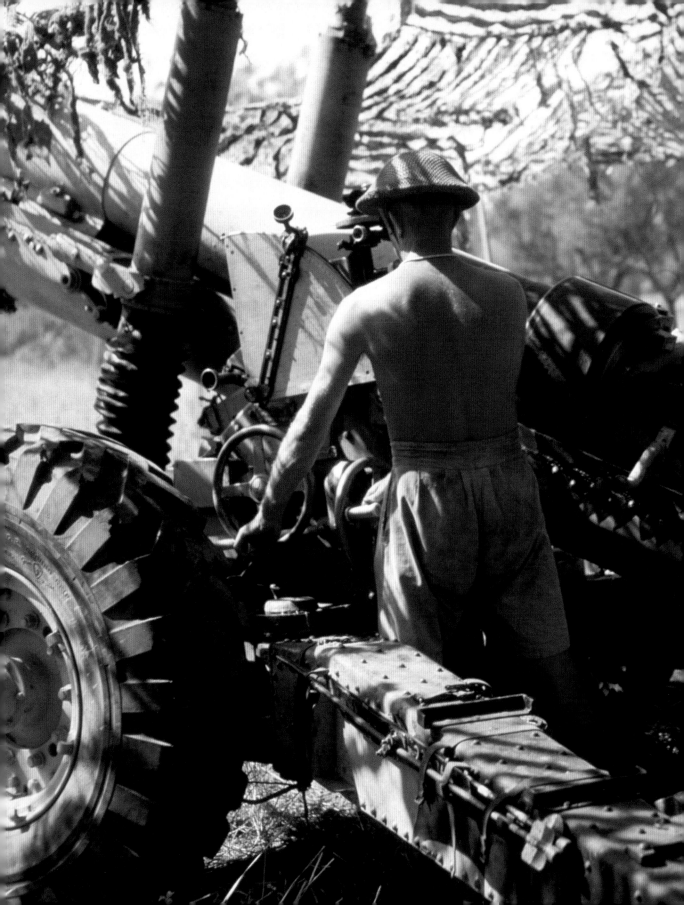

A 5.5-inch gun crew from 75th (Shropshire Yeomanry) Medium Regiment, Royal Artillery, in action in southern Italy, 22 September 1943. Mussolini had already been deposed, but Hitler refused to give up Italy, choosing instead to hold as much ground as possible. The advance northwards of the US Fifth and British Eighth armies was hindered by the Apennine Mountains, across which the Germans created a succession of defence lines. Allied progress was eventually brought to a halt south of Rome along the heavily fortified 'Gustav Line', which stretched from the mouth of the Garigliano River in the west, to Ortona on the Adriatic coast.

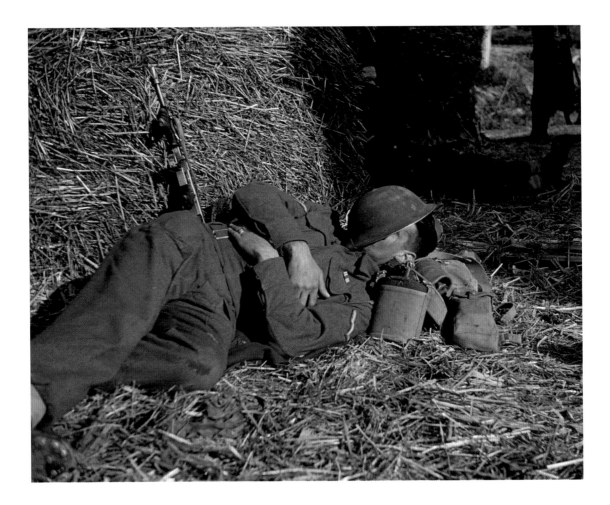

▲ **Lance Corporal A Durrant, an infantryman in 56th (London) Division, snatches some sleep during a lull in the fighting in Italy, 19 January 1944.** He wears the Africa Star medal ribbon, denoting service in the Western Desert or Tunisia. The 'Black Cat' Division – named for its formation badge depicting Dick Whittington's famous cat – served briefly with the Eighth Army in Tunisia before being despatched to join British X Corps, attached to the US Fifth Army, in Italy. When this photo was taken the troops had just taken part in the assault crossing of the deep and fast-flowing Garigliano river on the southern flank of the 'Gustav Line'.

▶ **A pair of Spitfire Mk IXs from 241 Squadron skirt the imposing slopes of Mount Vesuvius, looming above Naples, 27 January 1944.** The squadron specialised in tactical reconnaissance and ground attack duties. On 18 March the violence of war was briefly eclipsed by that of the volcano, which was the scene of a major eruption over several days. Three Italian villages were wiped out. The rain of hot ash and pumice also wrecked many American B-25 Mitchell bombers of the 340th Bomb Group on the ground at their airfield near Pompeii.

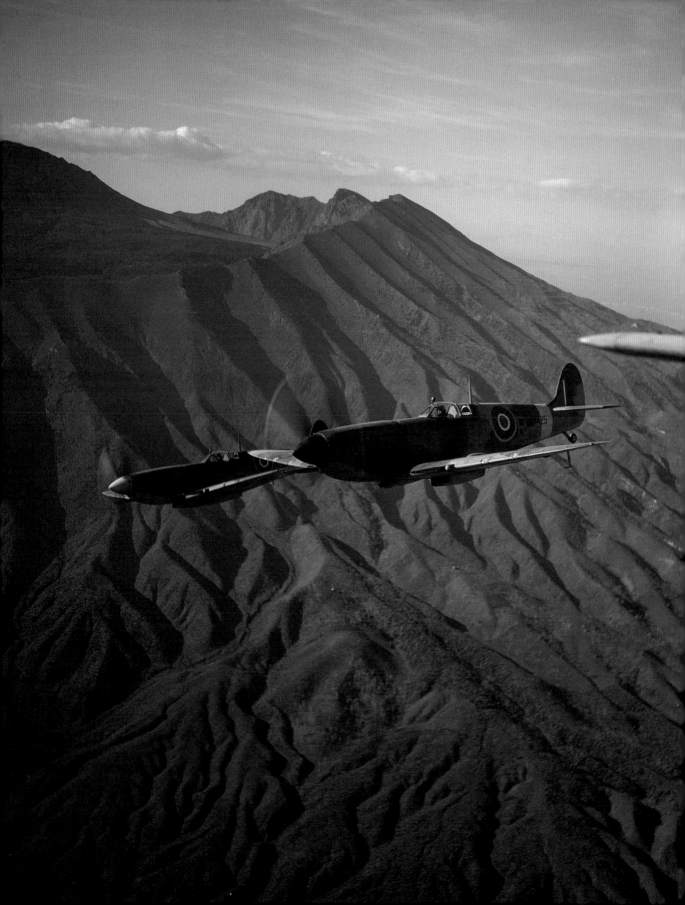

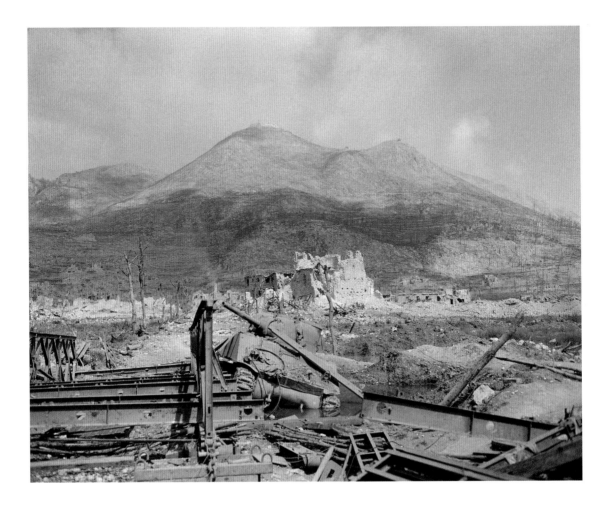

The town of Cassino and the mountains around it were key to the German defences of the 'Gustav Line'. From January to May 1944 US and British forces staged several major attacks in an effort to open up the road to Rome. The towering Monte Cassino, with its ancient monastery perched atop, was a principal objective. Allied bombing reduced both town and monastery to ruins, which were exploited by defending German paratroopers. After ferocious fighting, Allied firepower eventually prevailed. In a final battle, Polish troops drove the Germans from the heights of Monte Cassino itself. Here, a Sherman tank lies abandoned on the battlefield, 18 May 1944.

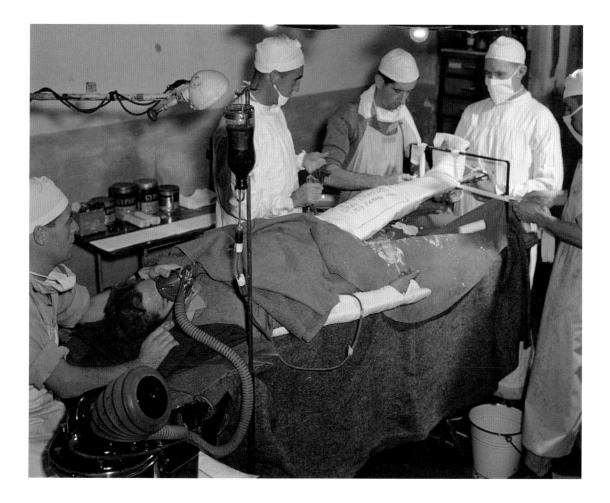

A British soldier is given a blood transfusion while his leg is set in plaster at an advanced dressing station in Italy, 7 October 1944. Allied armies benefitted from excellent medical services, and a wounded soldier's chances of survival were greatly improved by prompt transport from a regimental aid post, where he was stabilised, to a dressing station close to the front line where surgical treatment and blood transfusions were available. Another vital weapon in the medical armoury was the new antibiotic drug Penicillin, used extensively in the last year of the war to control infection.

A German Tiger tank lies immobilised on a road north of Rome, 18 June 1944. The capture of the city by the US Fifth Army on 4 June shone briefly in the headlines, but was soon eclipsed by the Allied invasion of Normandy. From then on the Italian campaign became a strategic backwater as Allied troops ground their way northwards. The Tiger had a fearsome reputation, but was poorly suited to the winding roads and steep terrain in Italy. Only two Tiger battalions served there, and lost most of their vehicles to breakdowns rather than Allied fire.

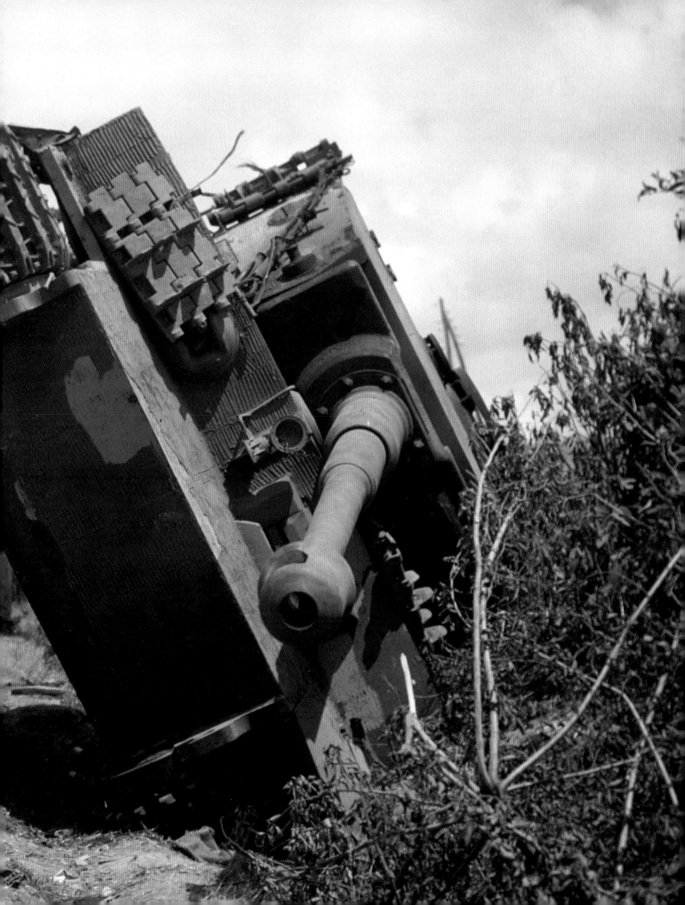

A Morris light reconnaissance car of the RAF Regiment alongside more traditional transport at Lajes airfield on the island of Terceira in the Azores, January 1944. In August 1943 the Allies reached an agreement with neutral Portugal and were allowed to establish military bases on the island archipelago. US Navy and RAF Coastal Command aircraft co operated on anti-submarine missions, providing vital air cover for Atlantic convoys bound for Britain or the Mediterranean. The Azores were also used as a staging post for US aircraft being delivered to Europe, and for flights evacuating the wounded back to the United States.

An RAF Bristol Beaufighter Mk VIC taxiing at Takali on Malta, June 1943. Malta was strategically vital to British interests in the Mediterranean. Submarines and aircraft based there were used to attack enemy convoys taking supplies to Rommel's forces in North Africa. From June 1940 to November 1942 the island suffered periods of intense bombing by Italian and German aircraft. Epic battles were fought to get supply convoys through to the besieged island. Malta and its population held out and were collectively awarded the George Cross by King George VI on 15 April 1942.

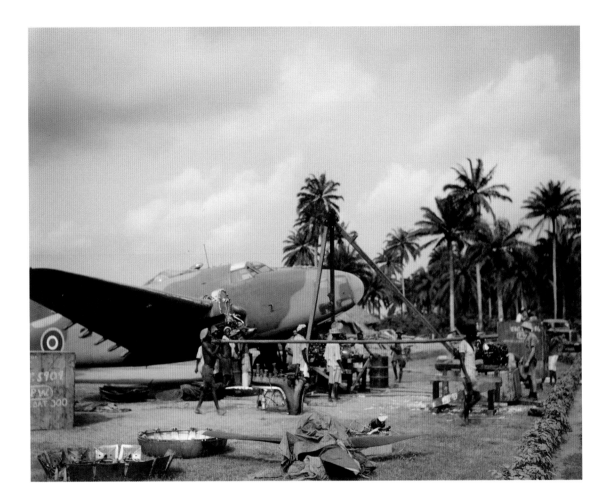

▲ Native workers assist RAF fitters carrying out an engine change on a Hudson of 200 Squadron at Yundum in the Gambia, April 1943. The squadron flew anti-submarine operations in support of Allied convoys off the West African coast. The British also established a major base at Takoradi on the Gold Coast (now Ghana), from where crated aircraft were prepared and flown 3,700 miles across the continent, via Lagos and Khartoum, to Cairo. 10,000 West Africans were recruited to support Allied operations in Nigeria, the Gold Coast, Sierra Leone and the Gambia.

▶ British soldiers admire the Porch of the Caryatids, part of the Erechtheum temple on the Acropolis in Athens, 21 October 1944. Germany invaded Greece in April 1941, in support of Mussolini's ill-fated attempt earlier. The country was subsequently plundered during a brutal occupation by Germans, Italians and Bulgarians. 70,000 Greeks were executed in reprisals for partisan activity. The Germans also deported and murdered 60,000 Greek Jews. British forces liberated Athens in October 1944, but conflict between rival political groups soon plunged the country into a bitter civil war.

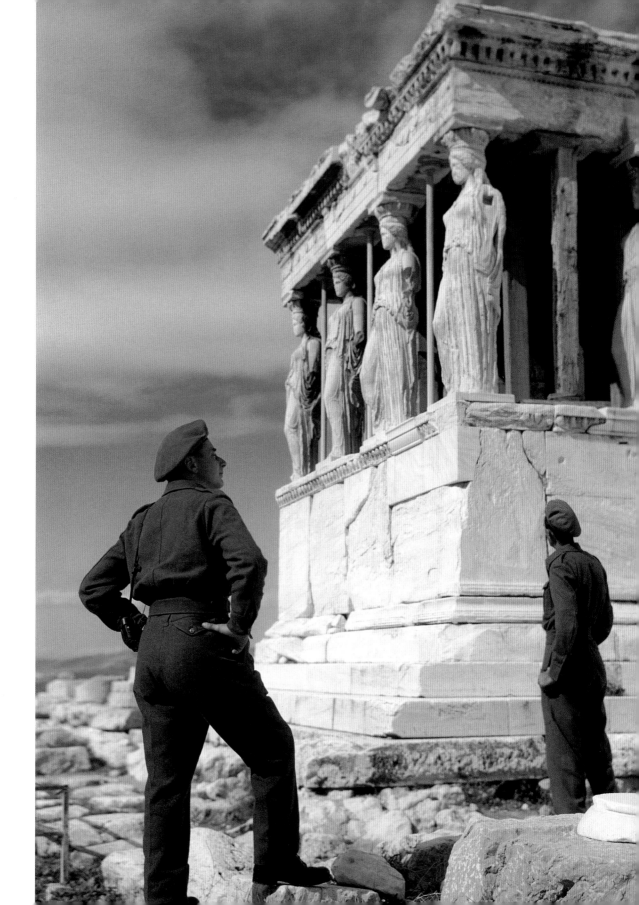

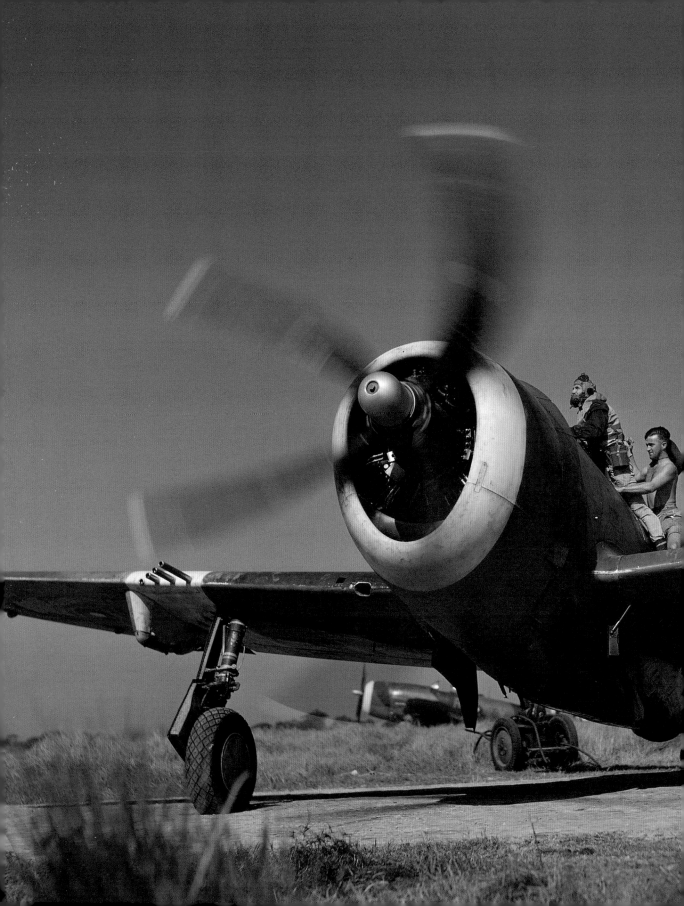

An RAF Thunderbolt Mk II pilot of 30 Squadron is helped into his cockpit at Jumchar, near Chittagong in India, at the start of a sortie over Burma, 15 January 1945. The RAF was heavily involved in support of the British Fourteenth Army's successful offensive against the Japanese in 1944 and 1945, flying bombing, ground attack and supply-dropping missions. A total of 16 squadrons were equipped with the sturdy American-built Thunderbolt, which was used for ground attack or long-range escort duties. This aircraft wears the standard white identification markings for the Far East theatre.

SECOND FRONT

On 6 June 1944 the Allies carried out the largest amphibious assault in history. After months of preparation and training 156,000 British, Canadian and American troops were landed on the coast of Normandy, with massive air and naval support. It was the beginning of Operation 'Overlord' – the campaign to liberate north-west Europe from Nazi rule. The opening of the Second Front effectively sealed the fate of the Third Reich, now sandwiched between the western Allies and the Soviet Union. Many of Hitler's elite armoured divisions had to be deployed to France, weakening the Eastern Front at a critical time. Russian forces had already inflicted major defeats on the German Army at Stalingrad and Kursk, and were now advancing westwards into Poland and up to the borders of Germany itself.

D-Day was a dramatic success, but Allied forces got bogged down as German reinforcements arrived and resistance stiffened. The Normandy campaign became a brutal slogging match, despite Allied command of the air and superiority in firepower. The priority for the British in the east of the bridgehead was the city of Caen, which was eventually captured after several set-piece attacks by General Montgomery. The Americans meanwhile took Cherbourg and then pushed south, finally breaking out from Saint-Lô into Brittany and the French interior at the end of July. The Germans had kept the Allies bottled up for six weeks, but their forces were now reduced to shattered remnants. They began a full-scale retreat from France, pursued by Allied units and harried all the while from the air. In August Allied troops landed in southern France, and quickly captured huge swathes of territory.

By early September Belgium was liberated, but with their supply chains stretched to the limit the Allies could not sustain their advance, and German forces were able to regroup. Montgomery, now a field marshal, proposed that all resources be concentrated for a push through Holland, bypassing the fixed German defences of the Siegfried Line. But his uncharacteristically audacious plan ended in failure at Arnhem. Supreme Allied Commander General Eisenhower, conscious of public opinion back home, switched to a broad front strategy. With US troops and materiel providing the bulk of the Allied armies, it was imperative that they be given a major role in the defeat of Germany. British, Canadian, American and Free French armies now all fought alongside each other to close up to the borders of the Reich, on a line that stretched from the North Sea to Switzerland. In October, US troops entered Aachen, the first German city to fall to the Allies. Yet operations were severely hampered by the onset of winter weather, and German forces fought back doggedly. There would be no quick end to the war.

In December Hitler launched his last-chance gamble in the west with a major counteroffensive through the forested and weakly-held Ardennes region of Belgium and Luxembourg. The objective was to cross the River Meuse, reach Antwerp and split the Allies in two. But only Hitler believed the operation could work, and after some fleeting initial success against inexperienced American troops the Germans were contained, and then forced into retreat. The 'Battle of the Bulge' drained the last of Germany's manpower and equipment in the west, and opened up the way for further Allied advances. The Soviets benefitted too, as they continued to push into south-east Europe, forcing Hitler's former allies Romania and Bulgaria to change sides, and moving into Yugoslavia and Hungary.

In January the Soviets launched an offensive into East Prussia, provoking widespread panic among the German population there.

In March 1945, after bitter fighting to clear areas west of the River Rhine, the Allies finally crossed this last great natural barrier barring access to the heart of the Reich. The British crossed north of Germany's Ruhr industrial region in Montgomery's last set-piece battle of the war. American forces were already across at locations further south. The Allied columns now advanced quickly, mopping up scattered German units and occasionally encountering fanatical resistance. The Third Reich was shrinking rapidly. Huge numbers of German troops were captured in the Ruhr pocket. Allied leaders had already agreed with Stalin that Soviet forces would take Berlin, and in April they launched their final offensive to capture the city. The ruined capital was fiercely defended, but finally fell after Hitler committed suicide. On 25 April US troops linked up with Soviet forces on the River Elbe, symbolically completing the dismemberment of Nazi Germany. The war in Europe ended with an unconditional German surrender on 7 May 1945.

PREVIOUS PAGE

Men from 53rd Heavy Regiment, Royal Artillery, ramming a shell into the breech of their gun during a bombardment of German positions around Caen, July 1944. This regiment was equipped with American-built 155mm guns, one of the largest weapons available to the British forces. The Allies in Normandy benefitted from prodigious fire support – from artillery, heavy bombers and even battleships anchored offshore. Throughout the war, the Royal Artillery was the most effective arm of the British Army, and the one most respected and feared by the Germans. Over 1.2 million men served as gunners – more than in the whole of the Royal Navy.

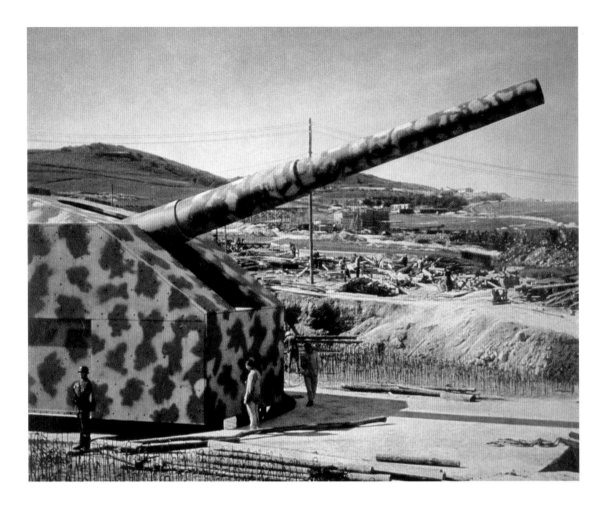

A 40.6cm (16-inch) gun of the German Lindemann Battery at Sangatte near Calais, 1942.
When this photo was taken the huge protective concrete casemates had not yet been completed.
This three-gun battery, and others like it, had originally been sited to shell Channel shipping and
the port of Dover. By 1944 the guns formed part of Hitler's 'Atlantic Wall', intended to deter an
Allied invasion. It was the presence of heavy artillery such as this that helped persuade Allied D-Day
planners to reject the heavily defended Pas de Calais in favour of the coast of Normandy.

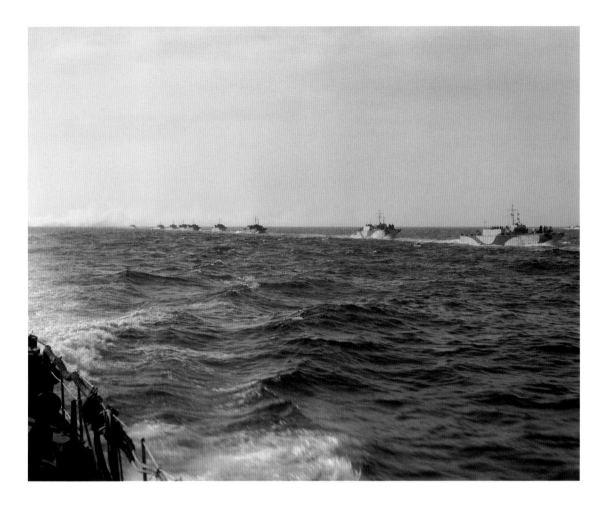

Infantry landing craft on an amphibious exercise in the English Channel, 1943. In the
lead is LCI(S) 512, later lost in action during the D-Day landings. Most landing craft were built in
America, but these particular vessels were designed by Fairmile Marine in the UK and assembled in
various small boatyards. They were used by the commando forces and each could carry 100 men.
Operation 'Neptune', the codename for the naval mission on D-Day, depended on the availability of
a host of specialised landing craft, from huge ocean-going tank landing ships to the small 'Higgins
boats' that carried a platoon of assault troops.

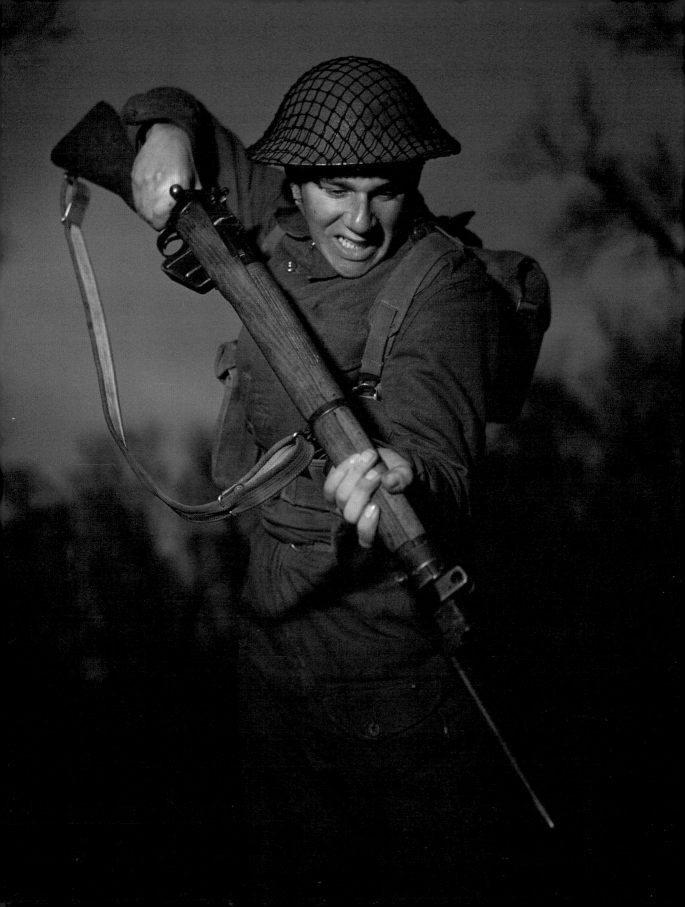

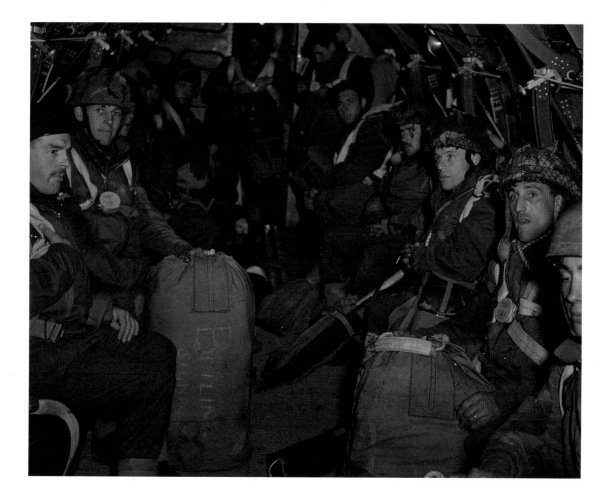

◀ **Private Alfred Campin of the 6th Battalion, Durham Light Infantry strikes an aggressive pose during battle training 'somewhere in Britain', March 1944.** Campin, a 23-year-old former bricklayer from Northampton, was, like many in his unit, a veteran of the North African and Sicily campaigns. Three battalions of the Durham Light Infantry collectively formed 151st Brigade, part of 50th (Northumbrian) Division. The formation had been brought back from the Mediterranean in preparation for D-Day, and would land on Gold Beach. Alfred Campin was killed in Normandy on 16 June 1944 and is buried at Bayeux War Cemetery.

▲ **British paratroopers prepare for a practice jump from an RAF Dakota based at Down Ampney in Wiltshire, 22 April 1944.** Allied airborne forces played a key role on D-Day, dropping in darkness to secure the flanks of the seaborne assault. Two American divisions jumped over the Cotentin Peninsula to the west of the invasion area. At the same time, the British 6th Airborne Division seized vital river and canal crossings across the River Orne in the east. Their most spectacular achievement came shortly after midnight on 5 June when a small glider-borne party landed with pinpoint accuracy and captured Pegasus Bridge over the Caen Canal.

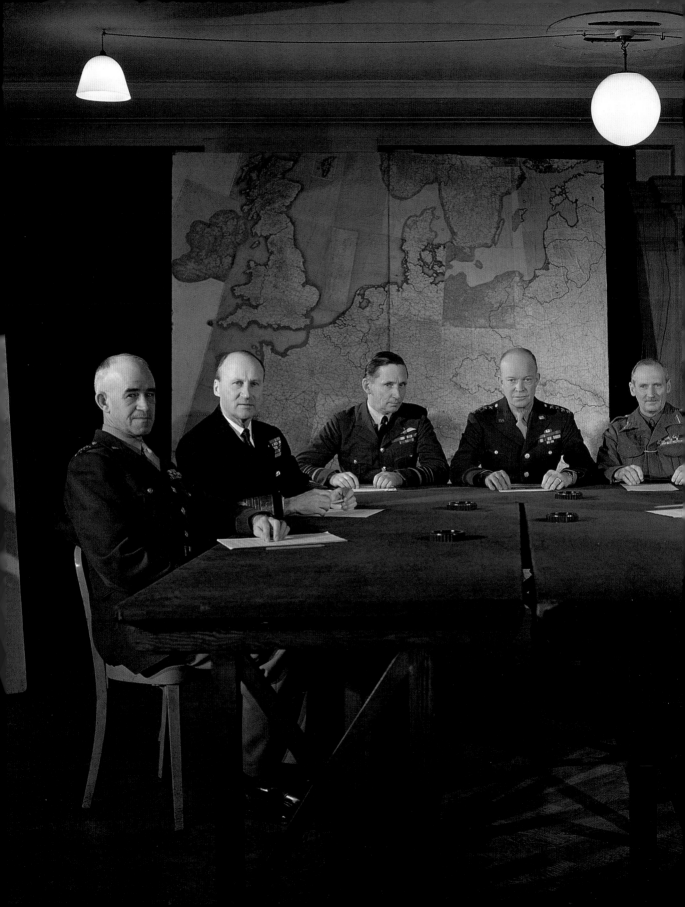

The man in charge of D-Day and the invasion of Normandy on 6 June 1944 was General Dwight D Eisenhower. Here he is seen flanked by his senior commanders at his headquarters in London, February 1944. From left, General Omar Bradley, Admiral Bertram Ramsey, Air Chief Marshal Sir Arthur Tedder, Eisenhower, General Sir Bernard Montgomery, Air Chief Marshal Trafford Leigh-Mallory, and Lieutenant-General Walter Bedell Smith. 'Monty' would command all Allied ground forces during the invasion. These men were ultimately responsible for the success of Operation 'Overlord', the re-conquest of north-west Europe.

▲ **British and Canadian troops join locals celebrating Bastille Day around the war memorial in Courseulles-sur-Mer, 14 July 1944.** The small fishing port was at the centre of the Canadian assault on Juno Beach on 6 June, and claimed to be the first French town to be liberated by Allied forces. By mid-July the Normandy campaign was still deadlocked. German forces, though massively reduced, were holding firm. Caen – the principal objective for D-Day itself – had only recently been captured. But at the end of the month US forces began a breakout from their positions in the west of the Allied lodgement area, precipitating a wholesale German retreat.

▶ **Wing Commander James 'Johnnie' Johnson with his pet Labrador 'Sally' and a Spitfire Mk IX at 'B-2' ALG (Advanced Landing Ground) at Bazenville in Normandy, 31 July 1944.** Within hours of D-Day the first airstrips were being built so that Allied aircraft could deploy to France. B-2 was ready by 16 June. Johnson commanded three Canadian Spitfire squadrons which collectively formed 127 Wing. He was the RAF's top scorer with 31 confirmed kills at this date. Although Allied air superiority was well established during the Normandy campaign, combats with enemy fighters became more frequent as Luftwaffe reinforcements arrived.

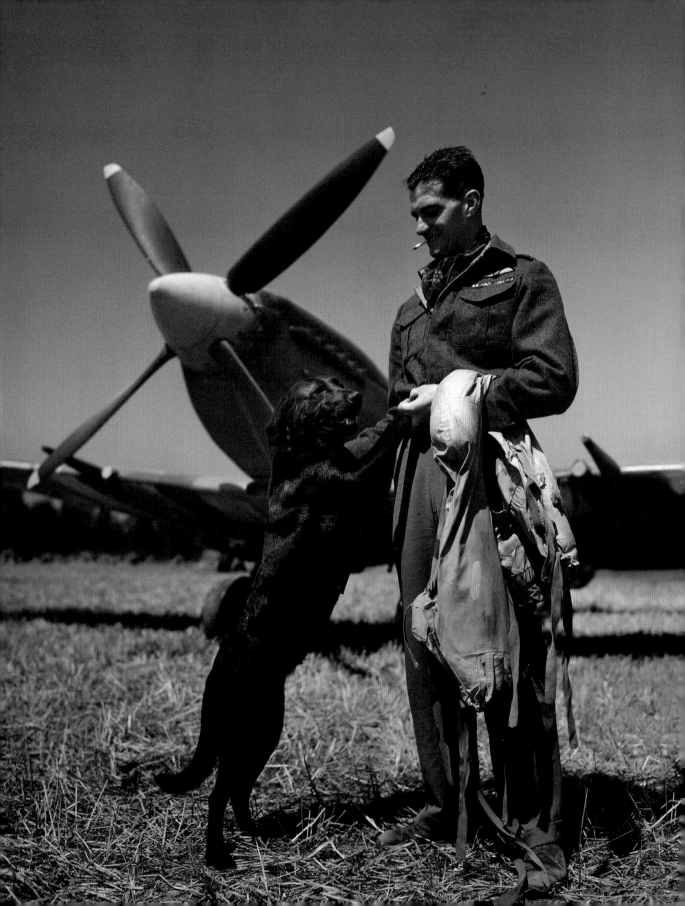

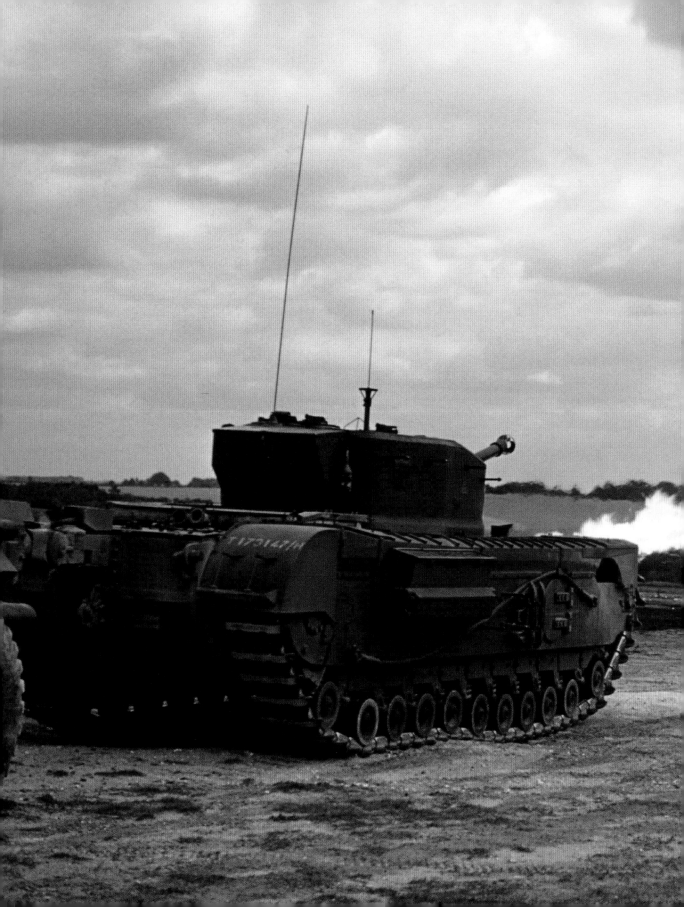

A Churchill Crocodile flamethrower tank in action during a demonstration, August 1944. Specialised armoured vehicles designed to clear mines, bridge gaps and demolish concrete bunkers played a key role on D-Day and in the subsequent north-west Europe campaign. These so-called 'Funnies' were operated by British 79th Armoured Division, and attached in small units to the various assault formations. The Crocodile was perhaps the most feared of these new weapons, and could blast a jet of flame up to 110 metres (120 yards) against pillboxes and bunkers. The very threat of its use was often enough to persuade enemy troops to surrender.

Abbé Gaston Saint-Jean, curé of Blainville-sur-Orne, a former French army officer and holder of the *Croix de Guerre*, baptises a baby in the chapel of the Château de Bénouville maternity hospital, Normandy, 27 July 1944. The hospital was only 5 miles from the front line, and artillery bombardments forced mothers and infants to spend much of the time in the cellars. The official photographer noted that since D-Day, 18 babies had been born — all girls. The hospital had been a hub of illicit activity during the German occupation. Weapons were stored there, and shelter given to shot-down Allied aircrew and civilians evading forced labour in Germany.

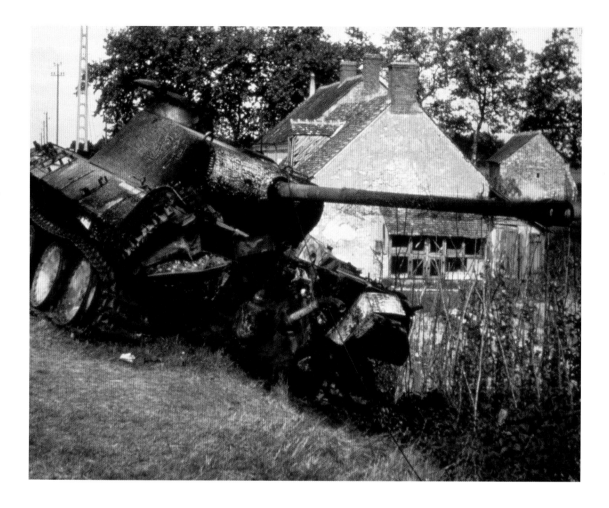

A German PzKpfw V Panther, burnt out in France, August 1944. The Panther was the most effective tank in Germany's arsenal, and was produced in higher numbers than the more famous Tiger. It's high velocity 7.5-cm gun was a powerful weapon, deadly to Allied tanks at ranges over a mile. In Normandy the Germans tried and failed to mass enough tanks to stage a decisive counterattack. Instead, the panzer divisions had to be used defensively, fed into the line piecemeal to support the hard-pressed infantry. Almost 2,000 tanks and armoured vehicles were destroyed or abandoned.

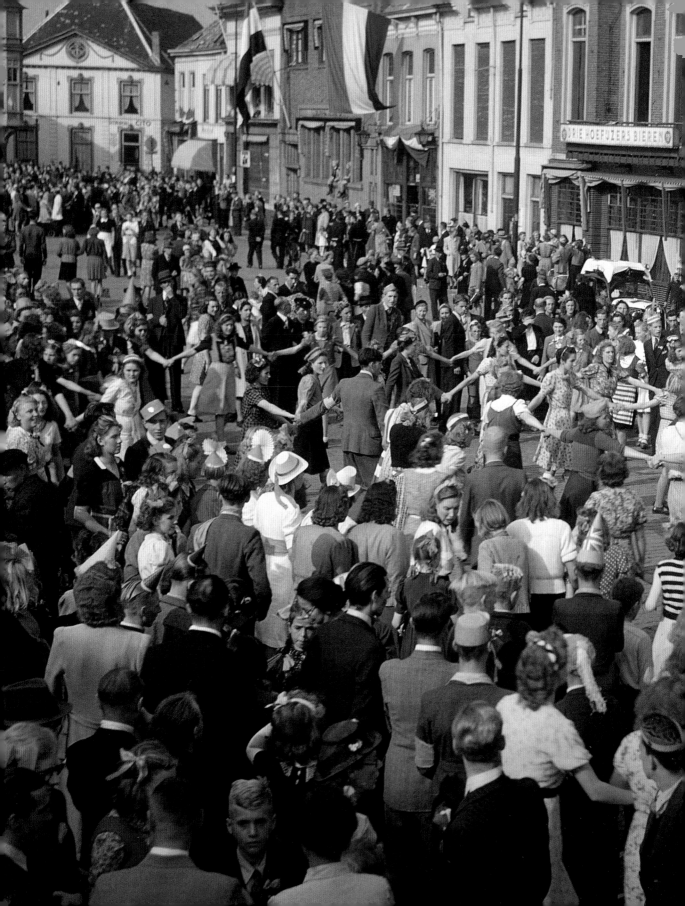

Dutch civilians dance in the streets after the liberation of Eindhoven by Allied forces, 19 September 1944. After the defeat of the Germans in France, Montgomery concentrated resources for a narrow thrust through the Netherlands and into northern Germany, bypassing the main enemy defences of the 'Siegfried Line'. The result was Operation 'Market Garden'. Three Allied airborne divisions were dropped into Holland to secure bridges in Eindhoven, Nijmegen and across the Lower Rhine at Arnhem. British armoured units began an advance along this corridor, but Arnhem proved to be 'a bridge too far'. The Allied advance was blocked and the British 1st Airborne Division virtually destroyed.

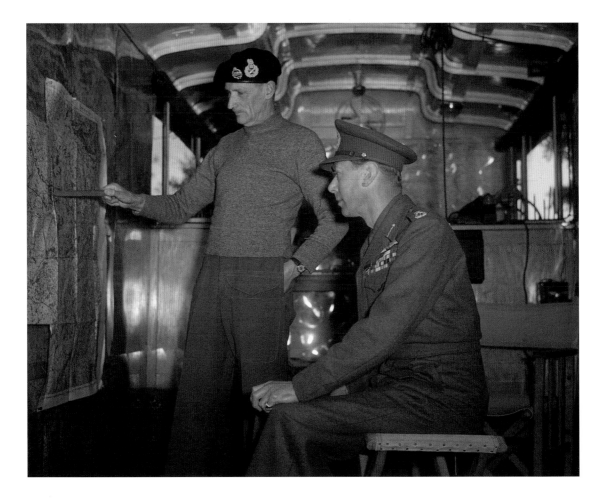

Field Marshal Sir Bernard Montgomery explains Allied strategy to King George VI in his command caravan at 21st Army Group headquarters in Holland, 13 October 1944. 'Monty' was a controversial commander. To many of his peers, especially the Americans, he came across as arrogant and abrasive, convinced of his own abilities and scathing of others. But he was revered by the British public and the troops under his command. He made important changes to the original D-Day plan, ensuring its success, but his reputation suffered after setbacks in Normandy and the failure of Operation 'Market Garden'.

B-26 Marauders of the 397th Bomb Group, US Ninth Air Force, in the snow at 'A-72' ALG, formerly Peronne aerodrome, near Saint-Quentin in France, January 1945. The US Ninth Air Force was dedicated to tactical operations in support of Allied ground forces in north-west Europe, using fighters and medium bombers. In January 1945, its aircraft played a vital role in halting the surprise German counter-offensive during the 'Battle of the Bulge'. The Marauder was a sleek and effective bomber, but one that required careful handling. Its high landing speed resulted in many accidents when flown by inexperienced pilots.

An abandoned Messerschmitt Bf 109G at Fürth in Germany, May 1945. An American P-51 Mustang can be seen behind. In the last year of the war, Allied air superiority reduced the Luftwaffe to a mere shadow of its former self. German factories continued to produce aircraft right up to the end, nearly all of which were fighters. But combat attrition meant there were few pilots left to fly them, and almost no fuel, thanks to Allied bomber attacks on Germany's synthetic oil plants and the capture of the vital Romanian oil industry by advancing Soviet forces.

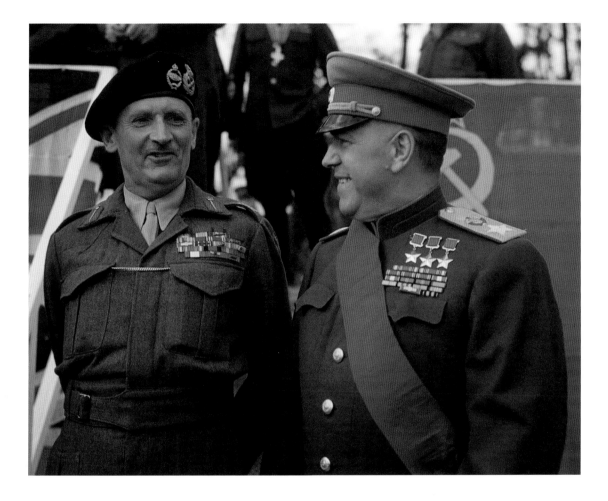

Field Marshal Montgomery with Marshal Georgi Zhukov at the Brandenburg Gate in Berlin, 12 July 1945. Zhukov, Soviet Deputy Supreme Commander of the Red Army, was the foremost Soviet general during the war, taking charge of the defence of Moscow and Stalingrad, and later playing a major role in the capture of Berlin. The smiles here hid tensions in the Allied camp. Stalin's forces occupied almost half of Germany and Berlin was a divided city, with zones of occupation assigned to Soviet, British, American and French forces. The defeat of Germany would usher in a new Cold War.

Image List

All images © IWM unless otherwise stated. Every effort has been made to contact all copyright holders, the publishers will be glad to make good in future editions any error or omissions brought to their attention.

Introduction
6−7 (TR 156)

Chapter One
10−11 (COL 149), 14 (COL 163), 15 (COL 293), 16 (COL 168), 17 (COL 158)

Chapter Two
18−19 (TR 139), 22 (HU 67287), 23 (TR 1928), 24 (TR 248), 25 (TR 185a), 26−27 (TR 1693), 28 (TR 219), 29 (TR 453), 30 (TR 572), 31 (TR 2835), 32 (TR 1386), 33 (TR 912), 34 (TR 2666), 35 (TR 941), 36 (TR 1169), 37 (TR 1783), 38 (TR 1580), 39 (TR 2858), 40−41 (TR 2876)

Chapter Three
42−43 (TR 1127), 46 (COL 193), 47 (TR 192), 48 (TR 186), 49 (COL 209), 50−51 (TR 11), 52 (TR 1554), 53 (FRE 5722), 54 (FRE 6887), 55 (FRE 6741), 56−57 (FRE 6210)

Chapter Four
58−59 (TR 1455), 62 (TR 94), 63 (TR 92), 64 (TR 2882), 65 (TR 284), 66−67 (TR 1082), 68 (TR 1138), 69 (TR 491), 70−71 (TR 2618)

Chapter Five
72−73 (TR 865), 76 (TR 1), 77 (TR 867), 78 (TR 884), 79 (TR 978), 80 (TR 939), 81 (TR 1244), 82−83 (TR 1402), 84 (TR 1529), 85 (TR 1534), 86 (TR 1799), 87 (TR 2410), 88−89 (TR 1920), 90 (TR 1496), 91 (TR 1064), 92 (TR 902), 93 (TR 2516)

Chapter Six
94−95 (TR 2637), 96−97 (TR 2052), 100 (COL 169), 101 (TR 1282), 102 (TR 1596), 103 (TR 1662), 104−105 (TR 1541), 106 (TR 2000), 107 (TR 2145), 108−109 (TR 2313), 110 (TR 2159), 111 (FRE 7407), 112−113 (TR 2369), 114 (TR 2393), 115 (FRE 7362), 116 (FRE 7652), 117 (TR 2917)

Acknowledgements

With thanks to the following IWM staff for all their work in helping to produce this book: Ted Dearberg, Amanda Mason, Stephen Long, Georgia Davies, Kay Heather, Caitlin Flynn and the IWM Publishing department.